Lavender
Fragrance of Provence

Hans Silvester

Lavender
Fragrance of Provence

New Edition

Text by Christiane Meunier

Translated from the French by
Alexandra Campbell and Lenora Ammon

HARRY N. ABRAMS, INC., PUBLISHERS

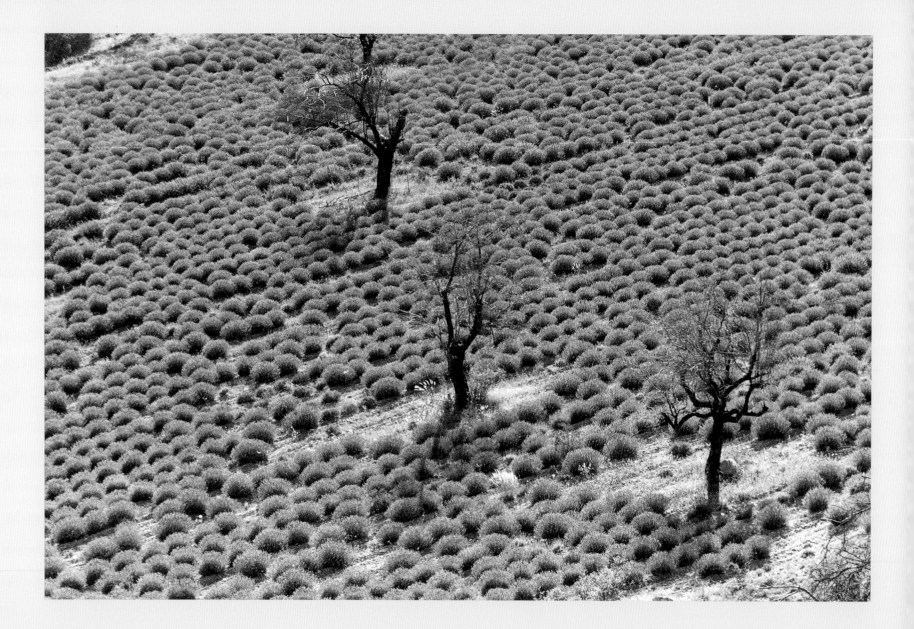

Lavender and its hybrid lavandin are found everywhere in Provence. In winter, the fields present a strict and bare geometry: plants are cut very short at harvest, and the branches bear only a thin grayish foliage. As soon as spring arrives, they turn a delicate green that intensifies as the season progresses. In June, flower buds appear and the wind blows through the pale purple fields. As the sun grows hotter, the flowers bloom into a dazzling violet-blue. Summer is here. This is a time of intense activity, when workers cut the flowers and distill their essences night and day. By the end of September, all the fields are harvested. After a torrid summer, the vegetation prepares for winter, which brings frost and sometimes even snow.

Each season offers a very different picture of the lavender and lavandin fields, but each has its own unique beauty, serving as symbols of the sometimes contradictory aspects of the Provençal character, which is both sad and happy, delicate and hardy. The fields are not all alike. Those of true lavender have a somewhat unique appearance (no plant resembles its neighbor in color or shape). The lavandin fields, on the other hand, are very regular and extend in perfect hedges that follow the gentle curves of the land. Cultivation is extensive and very mechanized on the plains and plateaus, while in the mountainous regions there are small and scattered fields, a patchwork that makes the best use of any cultivatable space.

In their different guises, lavender and lavandin fields are now an established part of the landscape and activities of the South of France, but it has not always been this way. This cultivation developed only at the beginning of the twentieth century.

Long before it was cultivated, lavender existed in the wild on the sunny, well-drained slopes at a minimum altitude of about 2,000 feet (600 meters). Like many other aromatic plants, including thyme, oregano, and sage, it belongs to the Labiatae family. The tissue of these plants contains specialized cells grouped in glands that secrete and store essential aromatic oils as the plant matures. In lavender, this essential oil is stored in the calyx of the flower. This essential oil (or essence) is extracted by distilling the flowering stalks in steam. Since secretion of essential oils—linked to photosynthesis and probably an adaptation to drought—is more intense in very sunny regions, Provence owes its fragrances

to the sun. Observation under the microscope shows a tight felting of hairs, which helps the plant conserve water and gives its surface a velvety appearance.

Since antiquity, there have been accounts of the use of lavender to scent and to disinfect, to heal, and to honor the gods. During the Middle Ages, references to lavender most often concerned medicinal uses. Much wild lavender was burned to disinfect houses and streets during plague epidemics. The illness was thought to be spread by smell, and scented fumigation was widely used to fight it. In the archives of many Provençal towns there are precise records of the sums spent by the community to buy vast quantities of aromatic plants to burn in the fight against contagion.

In Provence it was long ago observed that cuts suffered while harvesting lavender with a sickle never became infected and healed rapidly. Correlating with such therapeutic applications, the use of essential lavender oil greatly increased from the time of the Renaissance. This was stimulated by the proximity to the local town of Grasse, which the Italian Medici family (fourteenth to sixteenth centuries) turned into an important commercial center. Various industries developed and exploited local and back-country resources. The abundance of water and numerous flocks of sheep led to great activity for the tanning industry. The fashion of the time dictated that articles made of fine skin should be scented—especially gloves, which were an essential item of dress for any person of nobility. Therefore, along with its tanneries, Grasse developed a special know-how in the field of perfumery, and in 1714 the profession of "master glovemaker-perfumer" was created.

Soon the fragrance industry overtook all others and the production of ointments, soaps, cosmetics, and perfumes of all kinds became the town's most important business. The basic raw materials came from all over the world, though many were produced right in Grasse and the Provençal region of the lower Alps. To meet the increased need, the gathering of wild lavender, if at first sporadic on the arid hillsides of Provence, progressively became more organized.

At the beginning of the nineteenth century, industrial development led to depopulation of the countryside on an unprecedented scale. Many peasants left to work in factories or on the railroad, then under construction. The exodus emptied rural areas and created a new urban population.

From the earliest antiquity, rulers and nobles had been intrigued by fragrances. The well-to-do copied them and gradually perfume pervaded all social classes. An appealing symbol of luxury and success, fragrance is found throughout history, for example, the divine perfumes of Egypt and Rome, the fragrant spices of the Middle Ages, the scented skins (sometimes poisoned!) of the Renaissance, and the over-abundance of all types of fragrances during the seventeenth century that masked the rather questionable hygiene of the times. Perfume has had an indisputable place in history. During his exile, Napoléon could not import to Saint Helena the eau de Cologne he used in great quantities, so his servant created a substitute for him from native plants. The "recipe" was recently discovered in the drawer of a desk that once belonged to him. Reformulated by modern perfumers, it has enabled us to reexperience something of the olfactory atmosphere of Napoléon's exile.

Like clothing, perfume is a sign of elegance and upward mobility as well as one of the distinctive calling cards of the upper classes. People who moved to the towns and cities were particularly eager for these signs of refinement and did not hesitate to spend part of their earnings for themselves, and others, on these luxuries that had now become so necessary. Fashion was no longer reserved for the rich and idle elite; it touched all social classes. The perfume and cosmetics industry grew rapidly in France as well as in all the great cities of Europe and America. Grasse soon became the "perfume capital."

The demand for aromatic raw materials was constantly increasing and the rural life of the region was disrupted. From the self-sufficient economy, in which the farmers mainly consumed only what they cultivated, a market system developed. The arid and poorest mountainous areas were the first affected by the rural exodus. The abandoned land proved highly suitable for the proliferation of wild lavender. It grew well at that altitude and in the rocky soil that had been patiently worked by farmers for years. Now and then, flocks of foraging sheep dropped manure, which destroyed young trees and bushes whose shade inhibited lavender's growth. Eventually lavender spread to all the open spaces. Gathering and distilling became more systematic and were encouraged and organized by the industries of Grasse, which set up distilleries and brokerage networks in the far reaches of the back country.

At first the gathering of lavender was considered a source of supplementary income, a job for women and children or for shepherds and woodcutters in their spare time. Sickle in hand, they set off to cut wild lavender, then brought it back in large sacks suspended from their shoulders or simply carried it in an apron. In some regions an "apron" became the unit of measurement. This harvested lavender was then distilled in small stills heated by burning wood.

Beginning in the 1850s, heads of families took over operations—a sign of the new importance of this "side" activity in the local economy. Cutting operations were organized each summer. They included not only family members and neighbors but also seasonal laborers, most of whom were local workers but later immigrants from Italy, Spain, and North Africa. Teams of more than thirty people worked in the mountains throughout the week, sickle in hand, dusk till dawn.

The cut flowers were distilled in situ in portable copper stills, which were carried by donkeys or mules as the laborers made their way through the hills and set up beside the nearest source of water. In an effort to save time and energy, the trend was to increase the capacity of the apparatus, which then required a structure of fireproof bricks around the still and oven. Distillation became sedentary and the cut plants now had to be transported to the stationary distilleries. Any operation of importance owned its own still, and the perfume industry also set up its own facilities to encourage gathering and assure its supply of essence. The rural economy was profoundly altered: essential lavender oil could be sold immediately or stockpiled, making up a "cash" income as well as a way of saving that was practiced for years to buy more land, improve buildings and equipment, and handle exceptional expenses such as celebrations, dowries, travel, or family settlements. This new source of profit modified behavior and led to serious conflicts between the older generation, which mourned the lost of self-sufficiency, and the younger, which gave all its energy to this new, more profitable, and more risky activity.

The distillation and sale of essence gave rise to the occupation of broker-distiller practiced either independently or for a perfume company. Farmers who owned stills often distilled for their neighbors and thereby became producer-distillers, sometimes also acting as brokers, buying the distilled essences in order to resell them to interested industries.

This trade was based on a solid foundation of good relationships with producers, a good knowledge of industrial clients, and the ownership of a vehicle to collect and deliver the containers of essence. Brokers provided the link between producers and users for other agricultural products intended for industrial use, such as silkworm cocoons, fuller's teasel (for raising the nap on cloth), wool, and skins. Markets and fairs—at Sault, Carpentras, Forcalquier, Riez—brought everyone together to conduct business and exchange news.

Nowadays, modern means of communication have greatly contributed to the near disappearance of the traditional brokerage trade and have taken away from the crucial importance of fairs and markets for trading and fixing prices. At the end of the twentieth century, craftsmen also joined in the economic growth. Stills were usually made by local metalworkers or boilermakers, who continuously tried to improve them. Copper was the most commonly used metal because it could easily be worked with a hammer and was a good heat conductor. It was also used, along with tin and, later, zinc, to make tanks to hold essences. Small companies specializing in the manufacture of these products were created.

The profitability of lavender harvesting led property owners to encourage its proliferation. Wild lavender plants were thinned out when they became too crowded, and manure was sometimes worked into the soil. Growing bushes were systematically pulled up because lavender does not like shade. Moreover, considering the poverty and aridity of the soil, all other plants became dangerous competitors, to be eradicated so that lavender could thrive. These practices did not amount to cultivation in the fullest sense, but they were a way to enhance the natural proliferation of wild lavender without actually planting it. The idea of planting was often considered and even implemented, though without much success since young plants could not survive without watering.

Cultivation on a large scale was not practiced until the 1920s, and then not using lavender but a hybrid, lavandin. True lavender (*Lavandula angustifolia*) is occasionally found at very low altitudes (about 1,600 feet or 500 meters) in proximity to another plant of the same family called spike (*Lavandula latifolia*). Bees and the wind cross-pollinate lavender and spike. The seeds from this fertilization produce a hybrid plant, lavandin, which is almost always sterile. Local

people were long aware of this distinctive plant, which was better developed and hardier than its parent lavender and christened it "big," "great," or "bastard" lavender, but its precise identification was later made by scientists. Their work was directed toward the increase and control of the crop by cultivation to produce essential oils for industrial use, as well as to enhance agricultural development of impoverished regions, where the only livelihood was animal breeding and food crops.

In 1927 in the Chiris laboratories in Grasse—a local perfumery that has since disappeared—the artificial pollination of spike by lavender produced six seeds. Their seedlings produced two plants identified as "lavandin." This event marked the "discovery" of lavandin, but many other observations and research conducted at the same time led to a veritable explosion of lavandin cultivation beginning in the 1930s. The hybrid lavandin offers many advantages. It is a hardy plant that can adapt to difficult conditions and poor soil. It grows well even on the plains and provides a yield of essential oil that can reach ten times that of lavender. Thus cultivation first focused on lavandin, which is a sterile hybrid propagated

by cuttings. The cuttings, small branches usually removed in autumn from the adult or "mother plant," are put in nurseries. The roots develop in a few months and the plant is ready for cultivation after a year and a half.

This technique became widespread. Many mountainous land plots, as well as fields of several acres on the plateaus (e.g., Valensole in the Alpes-de-Haute-Provence region) were planted with lavandin. At the beginning, cuttings were taken from the first known or "common" wild lavandin found in nature. Around 1930, a more productive variety was developed by Professor Abrial, which bears his name, Abrial (or *Abrialis*). Up until 1960, it accounted for more than two-thirds of the planted areas. At this time, lavandin cultivation was afflicted by a wasting disease and life expectancy for the plants shrank from eight to ten years to three to four years. The search was on for more resistant varieties. These were the "Super" lavandins of the 1950s and 1960s followed by the "Grosso" variety, which has dominated since 1975. It is cultivated on three-quarters of planted areas, while the remaining quarter is divided among Super, Abrial, and Sumian, a close relative of Abrial. Cultivation of lavender was also mastered and would replace wild-lavender gathering, which

was still practiced until the 1950s. Lavender is grown from seeds because, unlike its hybrid lavandin, it is a fertile plant.

This mastery of lavender and lavandin cultivation led to the planting of extensive areas. Lavandin flourished since there was an increase in the industrial demand for lavandin essence, which was cheaper than that of lavender and well suited to soap making, and laundry detergents in particular. For essential oils, quantities are always expressed in weight and not volume because, unlike that of water, their volume density is variable.

In 1923 one hundred tons of essential lavender oil was produced, 90 percent of which was distilled from wild lavender. Around 1950, of the eighty tons produced, the proportions reversed, with 90 percent coming from cultivated lavender.

The production of essential lavender oil, competing against lavandin, imports, and synthetic products, has continually decreased, and in 1994 it had fallen to twenty-five tons. Thanks to the awareness of all the players in the market and to the growing success of aromatherapy, the downward trend was reversed. Fifty tons of essential lavender oil is now produced in France annually, about half of which

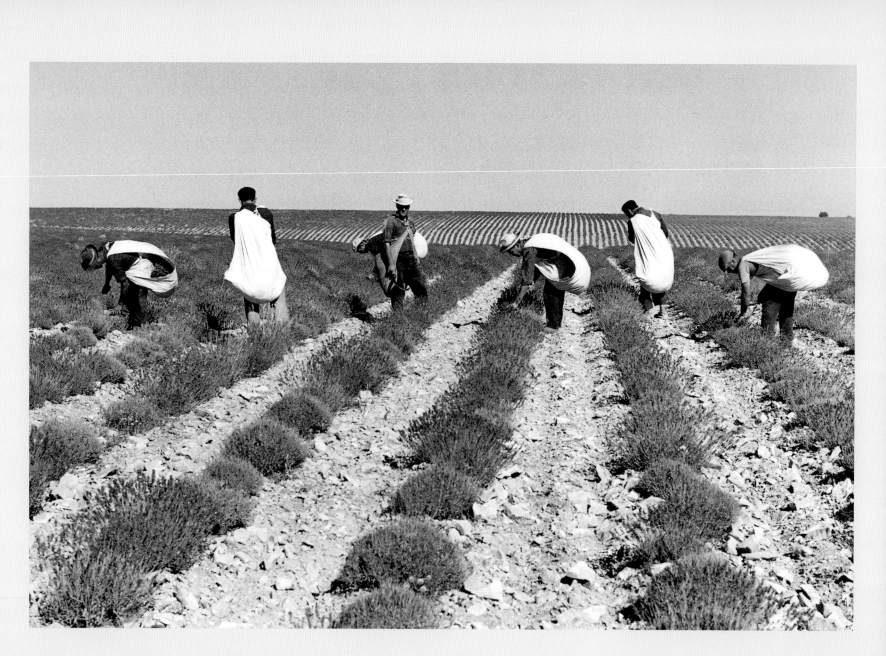

is derived from traditional true lavender, which is protected by an agency, the AOC (appellation d'origine contrôlée), and the other half from "clonals" propagated by cutting.

In 1924 the annual production of lavandin essence was 1 to 2 tons compared to 200 tons around 1950 and 1,200 to 1,300 tons today. Commonly used in mass-consumption perfumery, lavandin essence still has a good quality price ratio compared to competitive natural and synthetic products. The rapid expansion of the chemical industry after World War II led to an influx of synthetic products on the market, particularly from the petrochemical industry. These products, which imitate natural fragrances or create wholly original ones, quickly took the lion's share in all perfumery markets. The revived interest of consumers in "natural" cosmetics and aromatherapy has enabled lavender to survive, while lavandin has maintained a large base particularly in the detergent industry. This has been possible thanks to unceasing efforts to reduce production costs and the improvement of plants as well as cultivation, harvesting, and distillation methods, combined with the commitment of some manufacturers of finished products.

QUALITY

Quality can be measured using several criteria:

Volume of plant mass: The greater the volume, the larger the flower yield per hectare.

Vigor and longevity: The price of planting has a longer period of depreciation if the plant has a longer life span (almost eight years).

Suitability for mechanized cultivation: A plant with a long stem and deep roots can be harvested by machine more efficiently.

Essential oil yield: This is the percentage of the weight of the essential oil compared to the weight of the plant matter distilled. The producer wants the yield to be as high as possible.

Quality of the essential oil: Based on the very precise olfactory and analytic characteristics, the quality must respect the standards that correspond to industrial needs.

SELECTION

To attempt to unite all these qualities in a single plant, producers take cuttings from individuals that appear to have the desired volume, vigor, yield, and essential oil quality. Using this method, the producer obtains from the so-called "clone

head" plant a series of individuals that are all identical, constituting a clone (thus the homogeneous appearance of lavandin fields).

Research undertaken in this field over the last thirty years has led to practical results. Aside from the plants obtained by traditional woody cuttings, there are also plants produced by green cutting. This method consists of removing the ends of young sprouting leaves, which are then raised in a greenhouse, in small pots of well-watered potting soil, where they are given the elements they need to grow. In about two months, the young rooted plants are ready for planting compared to the one to one-and-a-half years needed for the traditional method. These plants are more expensive but, raised in a protected environment, they are free of pathogenic germs and have a longer life span. The depreciation period for the initial investment is longer.

To further improve the health and varietal purity of plants, cells taken from an apical bud of a lavandin shoot are developed in laboratories. These cells raised in vitro multiply and form a seedling that will itself be propagated. These seedlings, transplanted in the greenhouse, are plants with a perfect genetic identity. Cutting techniques can also be applied to lavender to obtain the "clonal lavender" plants mentioned above. Fields of clonal lavender have the same homogeneous appearance as lavandin fields, since plants obtained from cuttings from the same individual are genetically identical. Plants in a traditional true lavender field, called a "population," on the other hand, are very hetero-geneous because they are obtained from seedlings that are each from a different seed with a unique genetic code. Clonal lavender is easier to cultivate and has a better yield than traditional lavender, which explains its growth success.

PLANTING

Planting is done in the fall or spring if a severe winter is forecast. The young plants suffer from frost and the icy winds of the mistral.

Cultivation methods determine the organization of the plantation: distances between the plants in the row and between the rows of plants are dictated by the size of the tractors and machines used. The eight-year life span of the planting partially explains the slow adaptation of the fields to the cutting machine, which came into use in the 1950s.

Cutting machines require plants that grow very closely together in a hedge that is as uniform as possible. It is best to have a maximum number of plants per hectare. However, each plant must be able to develop a deep, branching root system to find enough water and food. The right balance must be found between the plant's needs, the size of the tractor, and different tools, as well as the need for maneuverability.

Planting methods are also mechanized; a planter, adapted from a tobacco or potato planter is used. There are about 10,000 plants per hectare (2 1/2 acres) for lavandin, and 12,000 to 15,000 for lavender. The plants obtained from green cuttings, very much alike in regard to size and shape, are easier to plant and generally better adapted to mechanized cultivation.

CROP MANAGEMENT

Plants have a special need for water when they are planted and some planting machines have an apparatus that waters each plant to help it take root. In autumn, after the stress of draught and machine cutting, the plants are very thirsty. They have to count on the heavy rains of autumn because there is no watering system.

The fields are weeded once or twice a year by hand, mechanically, or with weed killers. Weeds take water out of the soil, which already contains so little and obstruct the cutting tools. Moreover, during distillation, they can create abnormal odors and colors in the essential oils.

Beginning in 1935, phytosanitary problems appeared, especially in areas of intensive production. The fight against diseases and parasites was carried out by the usual means, but for the past twenty years, focus has been placed on the quality of the plant itself, the reconstitution and maintenance of soil and the diversification of crops. Crop rotation is done with durum wheat, soya, and sunflowers, or green fertilizer is used on dormant fields. These other crops are not harvested but buried in the soil to regenerate it.

HARVESTING

The best yield in essential oil is obtained when 80 percent of the flowers are in full bloom, or even slightly withered.

Although the first cutting machines were invented in 1925, it was only in the 1960s that machine cutting became widespread. At first, only the large lavandin fields on level ground were machine-harvested. Gradually, both machines

and planting methods were adapted, and today harvesting is completely mechanized. Harvesting about 2 1/2 acres (one hectare) with a sickle used to take two fast cutters two or three days' work. With a standard one-row machine, it takes only two or three hours. On large farms even faster machines are used that harvest three rows at a time. Traditionally, the flowering plants were cut, tied in sheaves, and left to dry a few days in the field before being transported to the distillery. This system is becoming obsolete with the increasingly frequent use of a method called "green grinding." At harvest, the flowering stalks are cut in small pieces by a chopper and put into a bin. When full, the bin is brought to the distillery where it will act directly as the distillation tank.

DISTILLATION

Steam distillation is thought to have been invented or at least improved by the Arabs. The method consists of passing a jet of steam through the matter to be distilled, which carries the volatile essential oil contained in the flowers' secretory glands. The mixture of steam and essential oil is then directed into a cooling system where it is condensed and transformed into a liquid. By natural decantation in the essence tank, the lighter essential oil separates naturally from the water and rises to the surface. The essence tank is equipped with two faucets: the one on top extracts essential oil and the one on the bottom drains the water.

The small copper stills, which were used at the beginning of the twentieth century and had a capacity of 200 to 500 liters (45 to 110 gallons), have been replaced by increasingly larger vessels. After 1950 the traditional still contained two tanks that worked alternately. Each had a volume of 1,100 to 1,300 gallons (5,000 to 6,000 liters) and could contain almost a ton (800 to 1,000 kilos) of plant matter, which was usually compressed by a tractor full of concrete. Water was not put into the tank, as had been done previously, but steam was produced outside by a fuel, oil, gas, or electric heater.

In the past, energy was produced by burning the distilled matter, but this posed problems for labor and the environment. Today, the steam jet is sent into the tank through the plant mass, carrying off essential oil. The flow is condensed in a coil plunged into cold water or into coolers (refrigerated tube bundle). It now takes ten minutes to distill a tank of lavender or lavandin. The yield in essential oil is

less than 1 percent for true lavender and 2 to 3 percent for lavandin, depending on the variety.

This type of distillery still exists, but for the past fifteen years, more than three-quarters of the production uses the "green grinding" method. At harvest time, tanks (usually 530 to 700 cubic feet or 15 to 20 cubic meters) are filled directly in the field and taken to the distillery. They are attached to a steam inlet and a refrigeration system; the tank itself acts as the still. When distillation is complete, tubes are attached, the tank is emptied, and the remaining plant matter is often used as fertilizer. In one to one-and-a-half hours, five to eight tons of plant matter can be processed, requiring a very reduced labor force. This explains the success of this system, inspired by the method used for mint distillation in the United States, regardless of the cost of investments and the energy needed.

MARKETING

Essential oils are marketed through the intermediary of specialized companies, cooperatives, a few brokers, and sometimes directly to independent producers. The latter case involves, in particular, the aromatherapy market, where

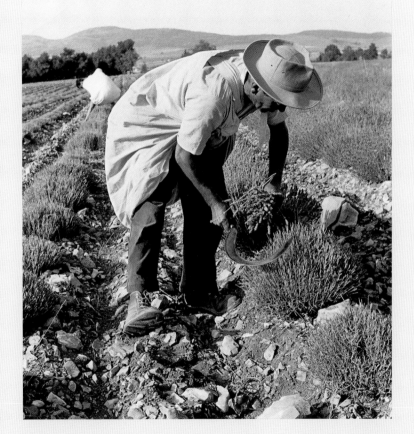

quantities are limited, rarely amounting to more than 440 lbs. (200 kg) and price is given less importance.

Lavender and lavandin essential oils are mainly intended for the perfume industry. They are never used pure, but combined with other natural or synthetic raw aromatic materials to build a "compound" intended to scent a specific medium (e.g., an alcoholic solution for an eau de toilette or a detergent base for soap or laundry detergent). To create a compound, the perfume creator has hundreds of raw materials available. They are chosen and put together based on the finished product the compound will scent, the olfactory characteristics and techniques desired, and the established price. Even if a formula contains lavender or lavandin, it will not necessarily be the dominant note. For this reason, the contributions of lavender and lavandin often go unnoticed by consumers and their noses. Some large perfume or soap-making companies have their own laboratories, but most of them call on specialized companies. These specialists offer a wide range of ingredients for all types of media and create customized fragrances as well.

The largest portion of the French lavender and lavandin production is exported. The main markets are the United States, Germany, England, and Switzerland. The other countries of Europe, as well as Latin America and Japan, are also big markets. Actually, all countries are consumers, either directly, if they have industries capable of using this raw material, or indirectly by buying perfumed compounds or finished products that contain them.

The largest customers are multinational companies that seek a regular supply, standard quality, and the best price. Therefore, there is competition between lavender and lavandin and other natural or synthetic raw materials. International competition exercises a strong pressure and adaptation to the industrial market demands that farmers make ongoing efforts. In regions where the geographical conditions permit it, mechanization has developed to the maximum and distillation infrastructures are well maintained and regularly renewed. Thus, there is a concentration of lavandin growing in the French regions of Alpes-de-Haute-Provence, Drôme, and Vaucluse. The total area of lavandin cultivation is about 65 square miles (17,000 hectares) and lavender, 15 square miles (4,000 hectares). Usually the production of about 2 1/2 acres (one hectare) is estimated at around 33 lbs. (15 kilos) for true lavender grown in a

"population," 77 lbs. (35 kilos) for clonal lavender, and 220 to 285 lbs. (100 to 130 kilos) for lavandin. These figures differ considerably depending on the region, climatic conditions, variety, and the age of the plants. The areas planted often vary due to market fluctuations and prices, and whether there are alternative productions.

For all the concerned regions, above all very mountainous ones, lavender and lavandin cultivation represents an important, if not the major, activity. It is part of a fragile and often very ancient economic balance. Bee keeping, for example, is traditionally associated with it. In this context distillation using the green-grinding method poses problems because it deprives bees of their favorite flower too quickly. Lavender growers also cultivate other aromatic plants and those used for perfume such as clary sage, tarragon, and rosemary. Plants adapted to local conditions, such as durum wheat and sunflowers, are found here as well. Small trees, young truffle oaks, are often seen in small lavandin fields. Before they grow and form groves, there is time to harvest lavandin and train a dog or pig to search for truffles, which always flourish under oak trees.

Lavender and lavandin fields are now so much a part of the Provençal landscape, it is easy to forget that they are in no way natural, but are the result of continuous and exacting labor that has turned a barren region into a veritable garden. Which is all the more reason to appreciate the magnificent images you are about to see on the following pages.

C.M.

All statistical data comes from the Annual Report 2004 of the Office National Interprofessionnel des Plantes à Parfums, Aromatiques et Médicinales at Volx (Alpes-de-Haute-Provence).

This book is dedicated to the farmers of Provence
who, by their toil, have beautified the land.

HANS SILVESTER

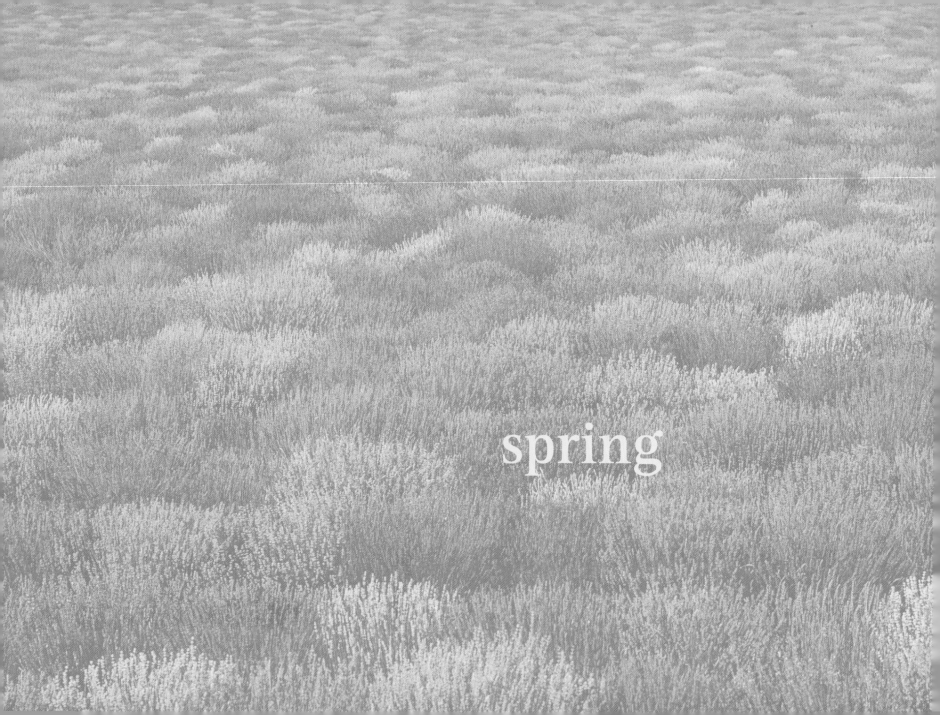

spring

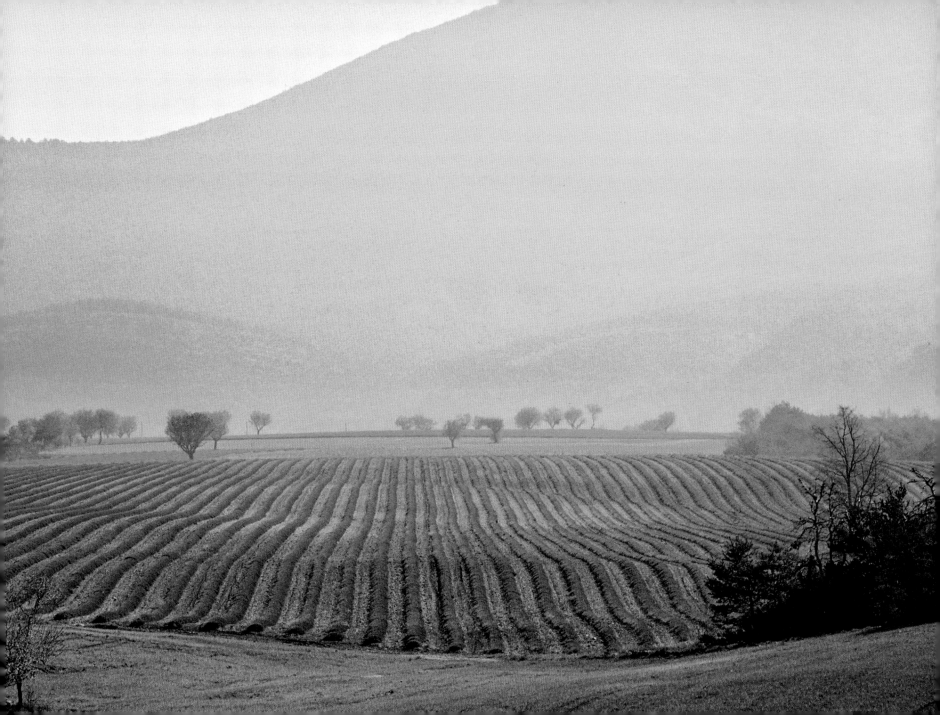

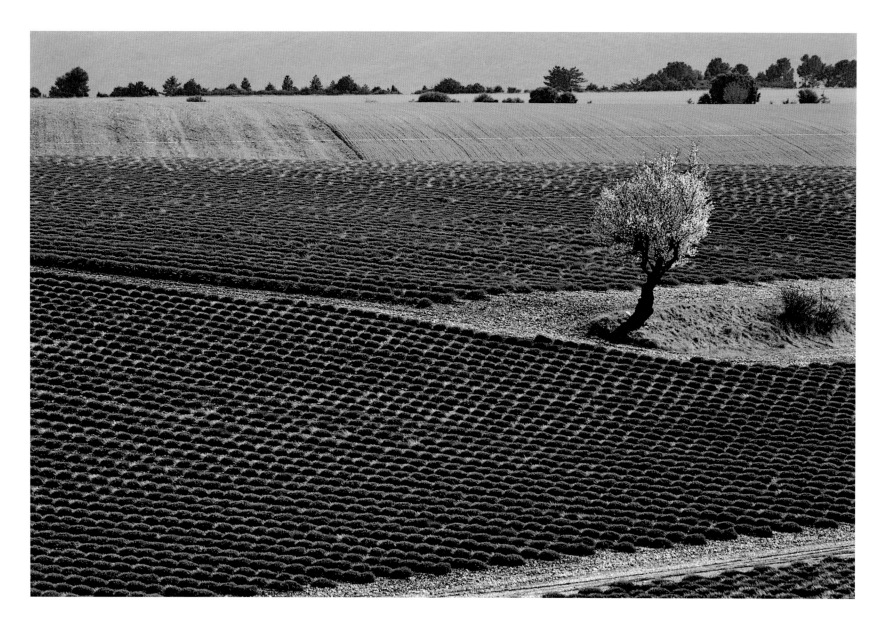

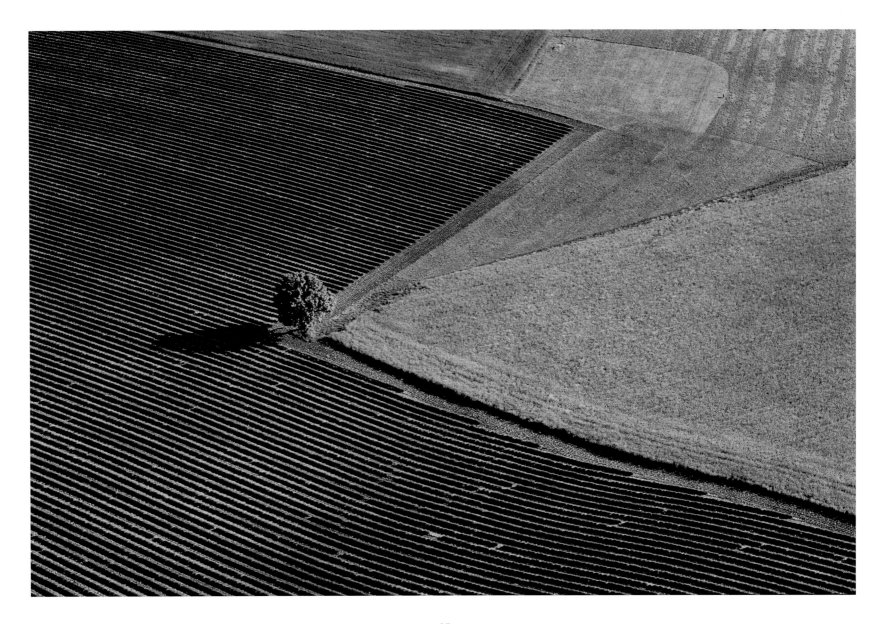

In Provence sweet almond trees

are the first trees to blossom,

even before spring arrives.

Like dazzling jewels they burst

forth in the lavender fields during

the first days of March.

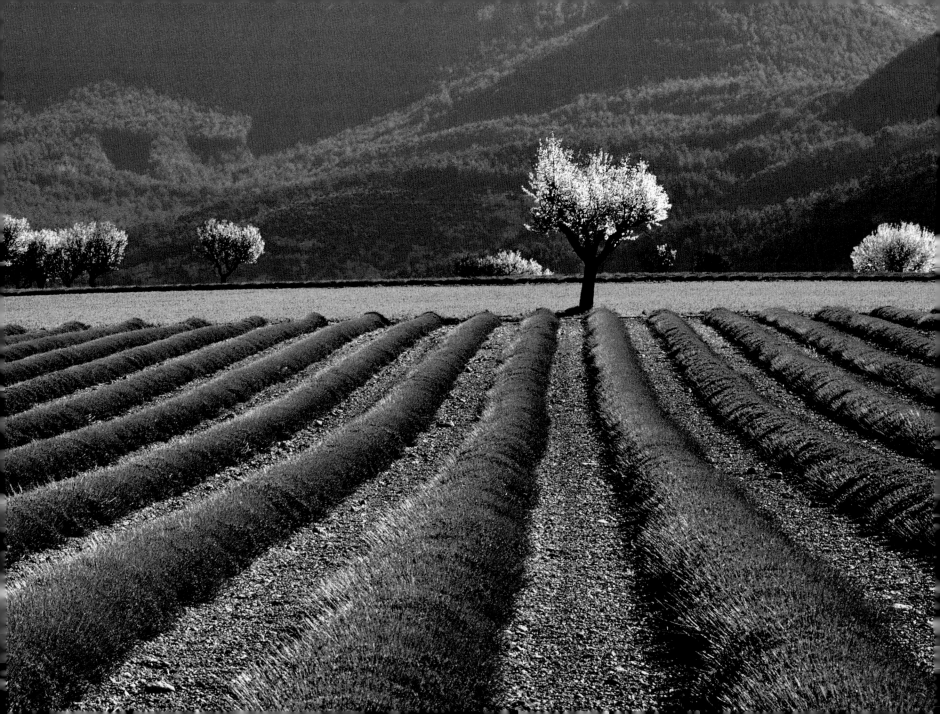

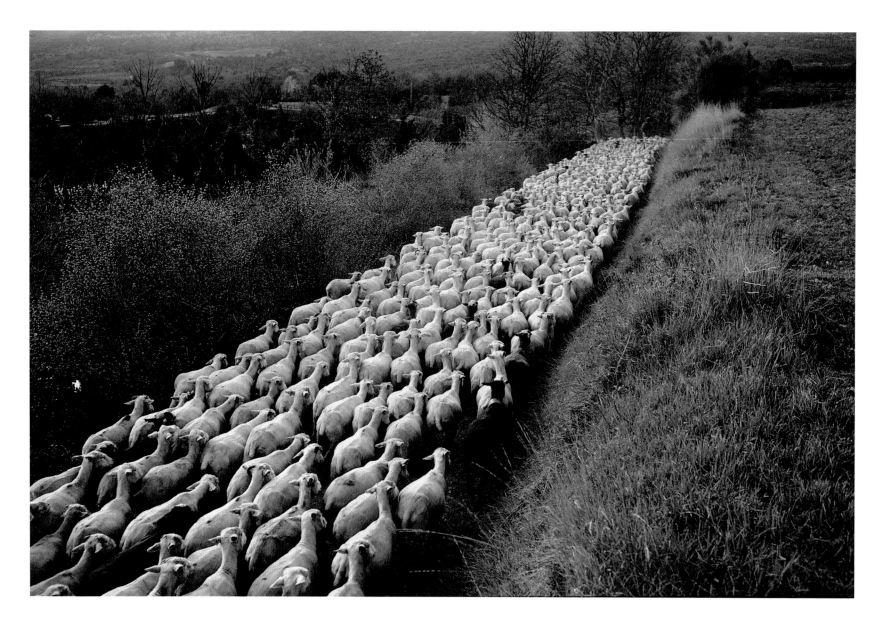

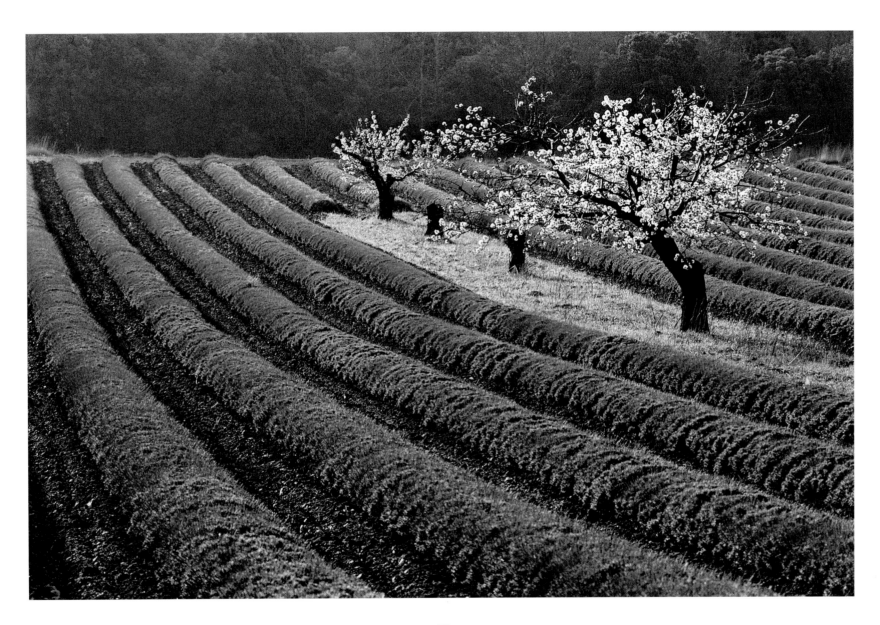

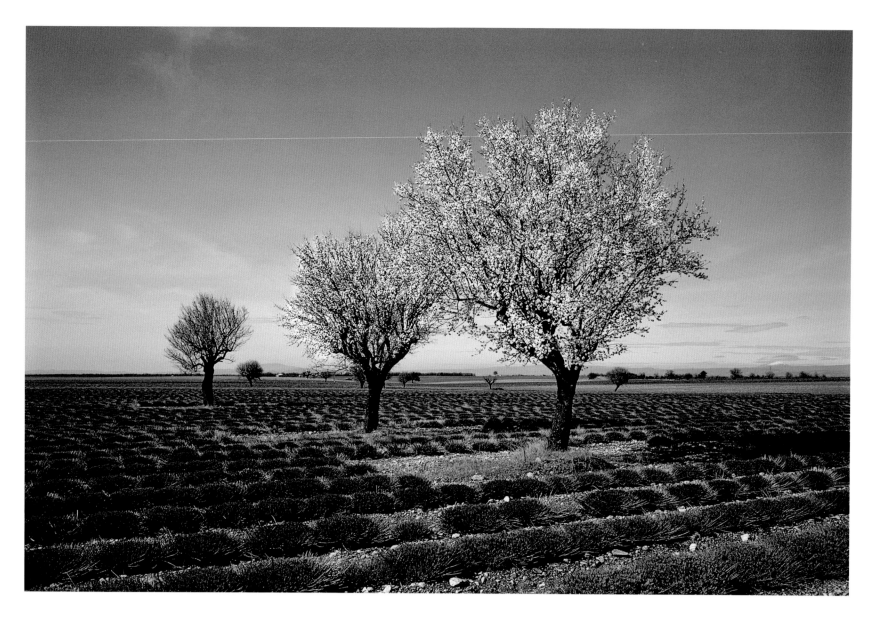

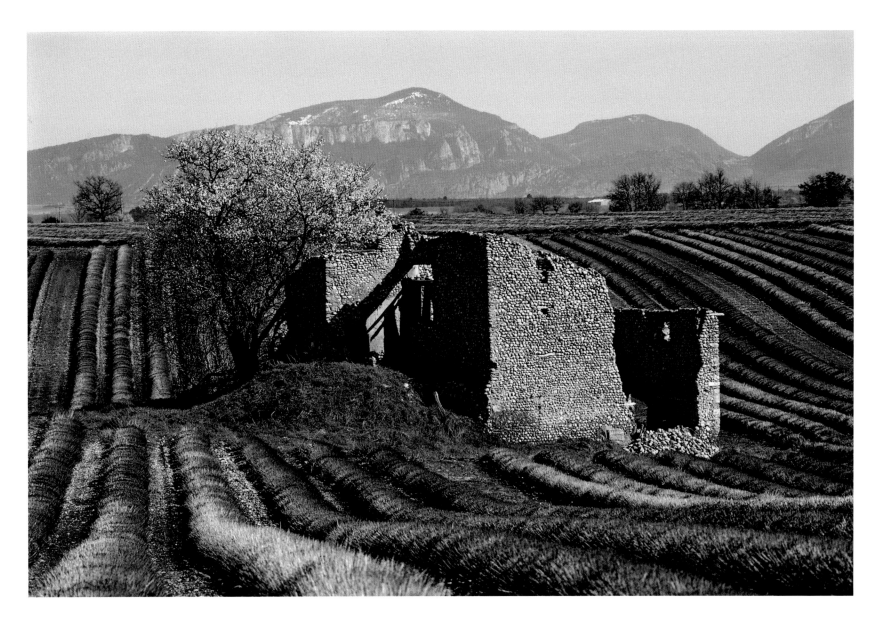

On the Valensole plateau, fields of wheat and lavender jealously guard their space,

creating a striking symmetry.

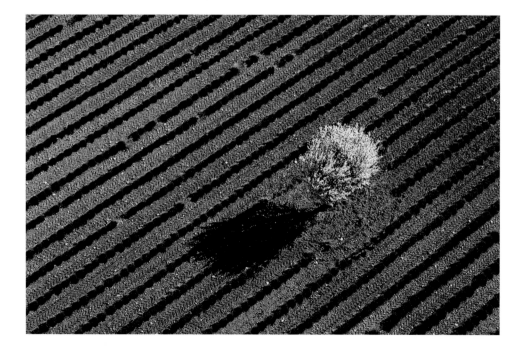

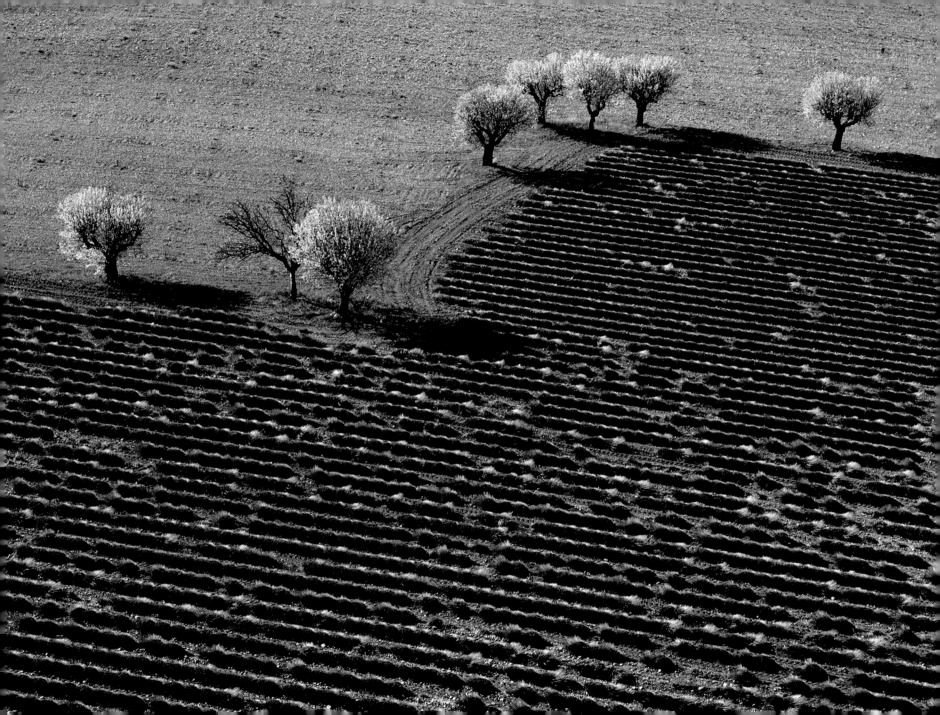

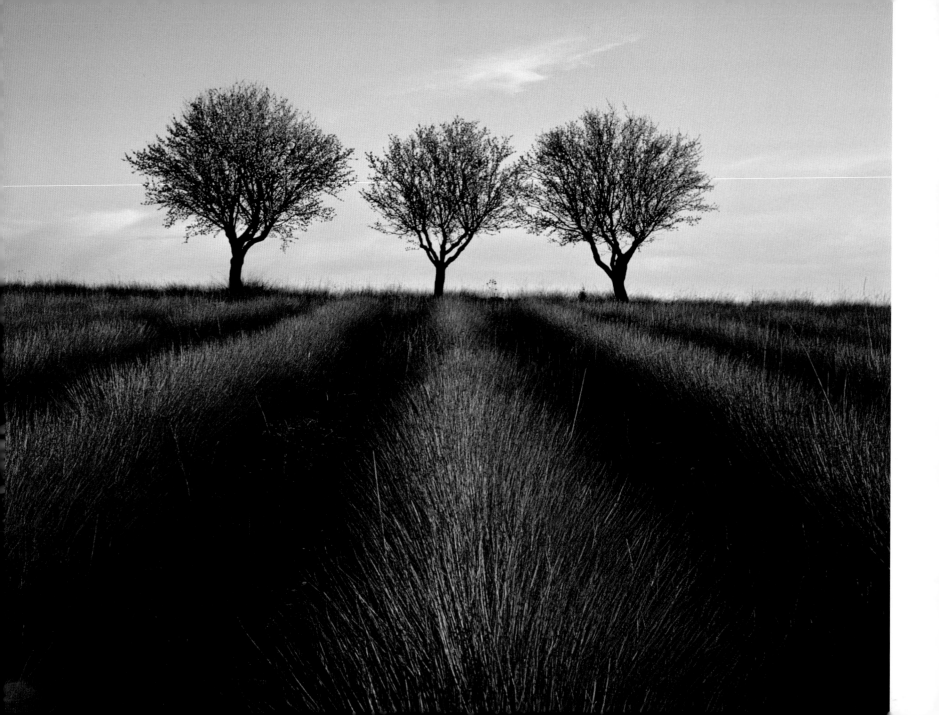

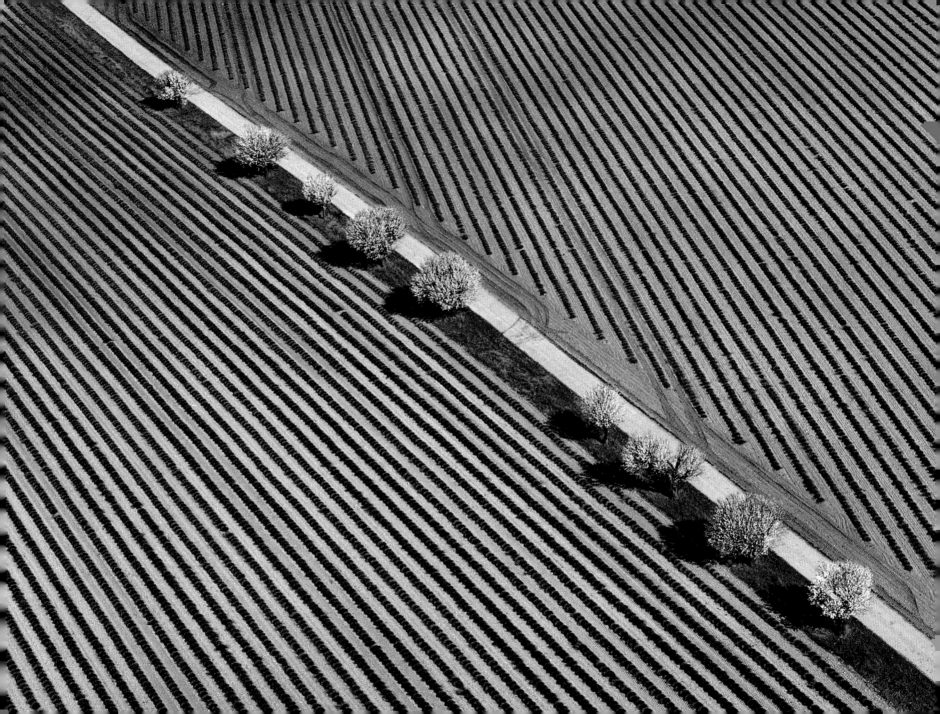

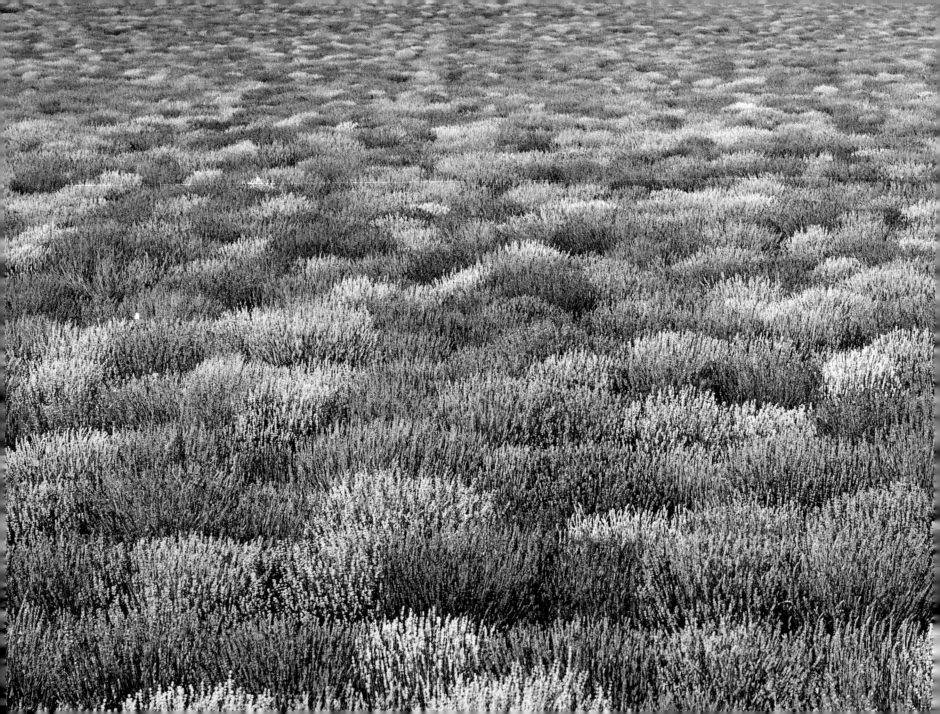

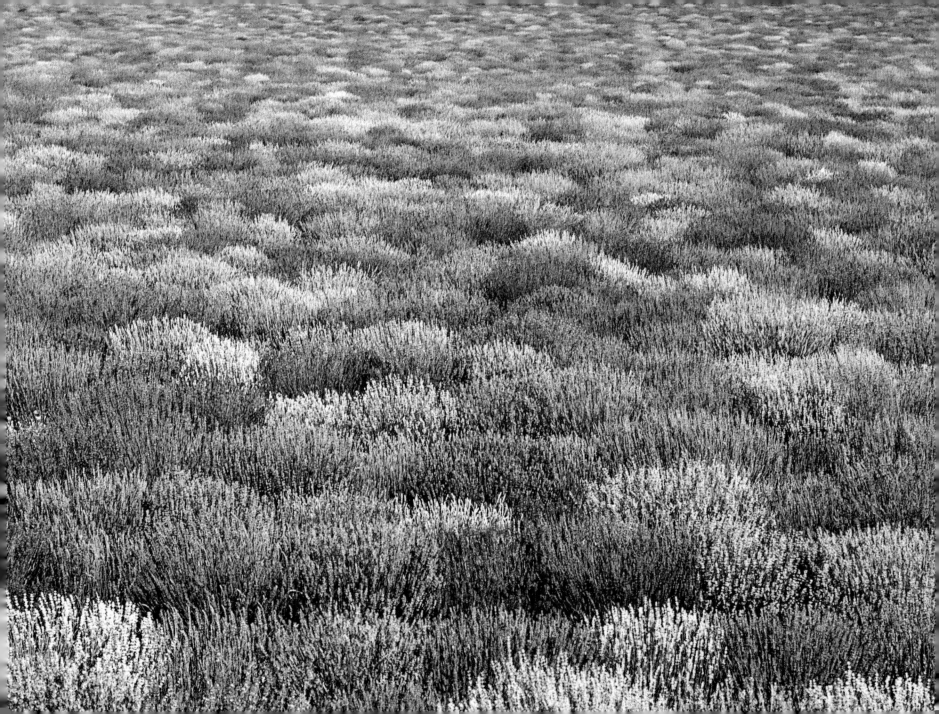

By the side of the peaceful

Sénanque abbey, wild broom

seems to have escaped from

the scrubland. These bright

yellow bushes form a natural

border between lavender plants

and other crops.

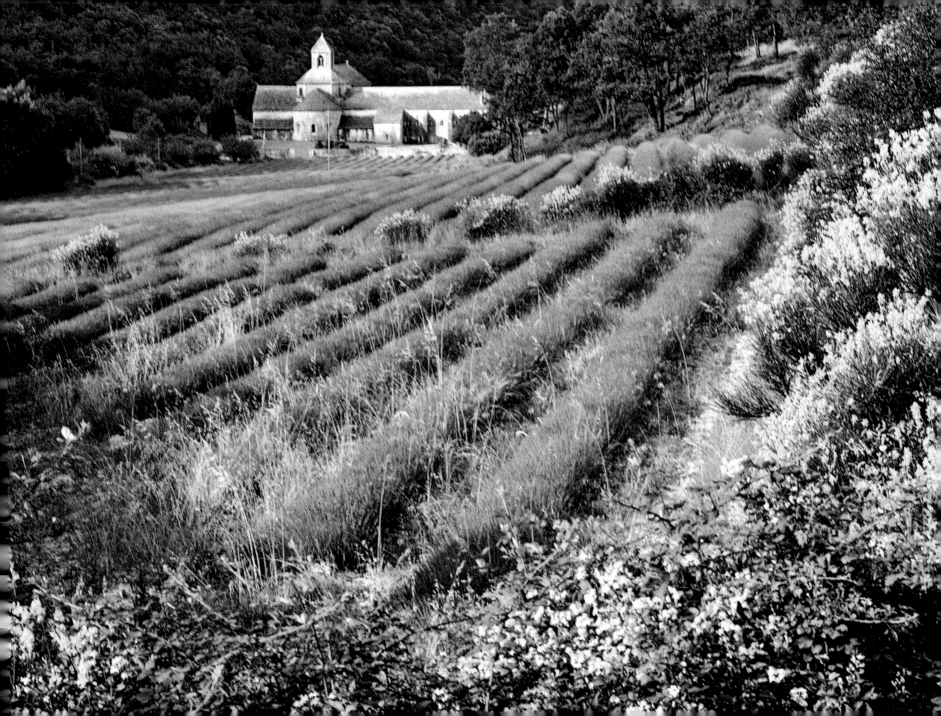

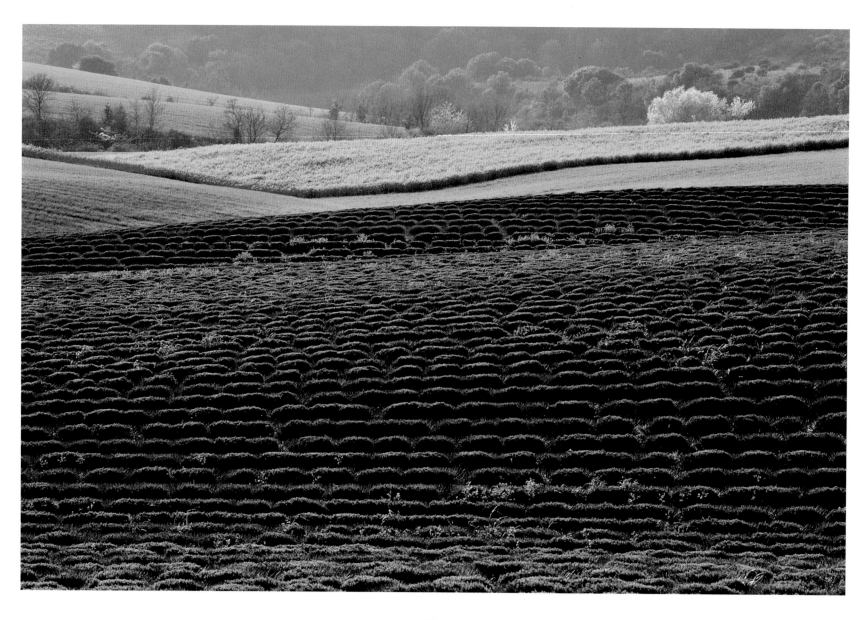

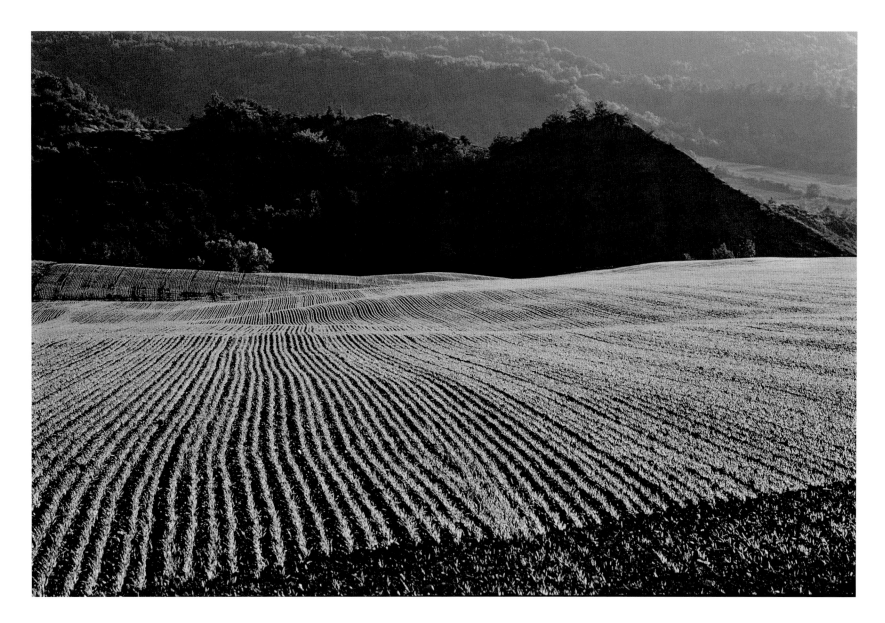

3

Extremely rare in lavender fields, olive trees usually prefer lower altitudes.

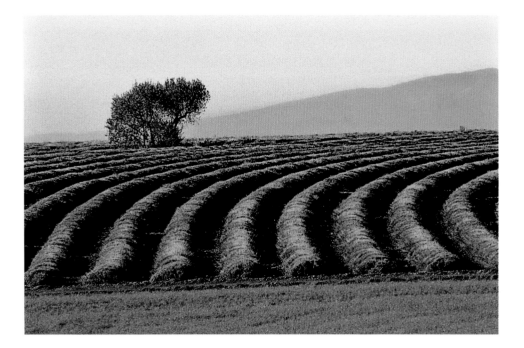

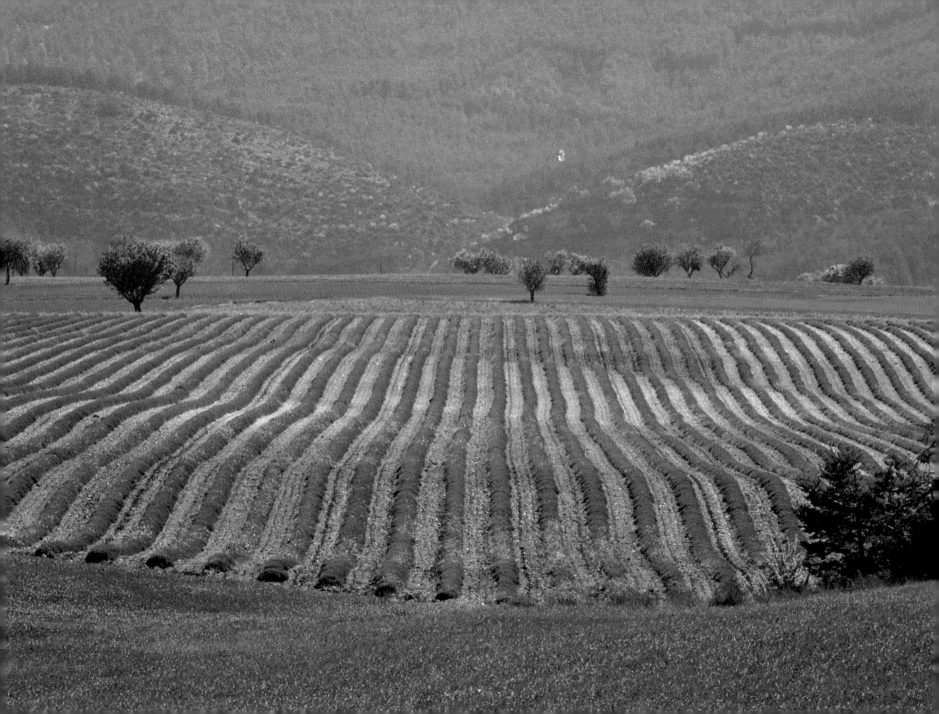

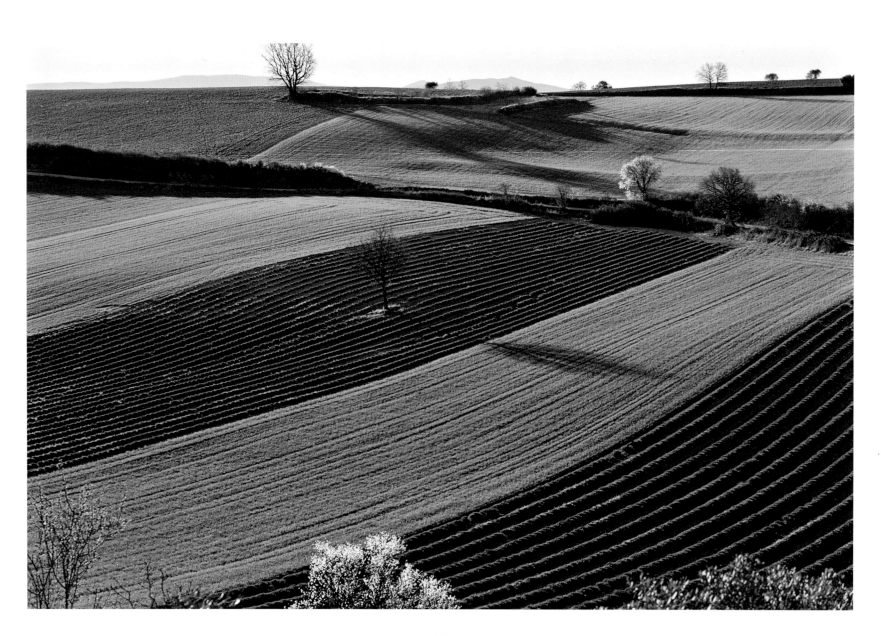

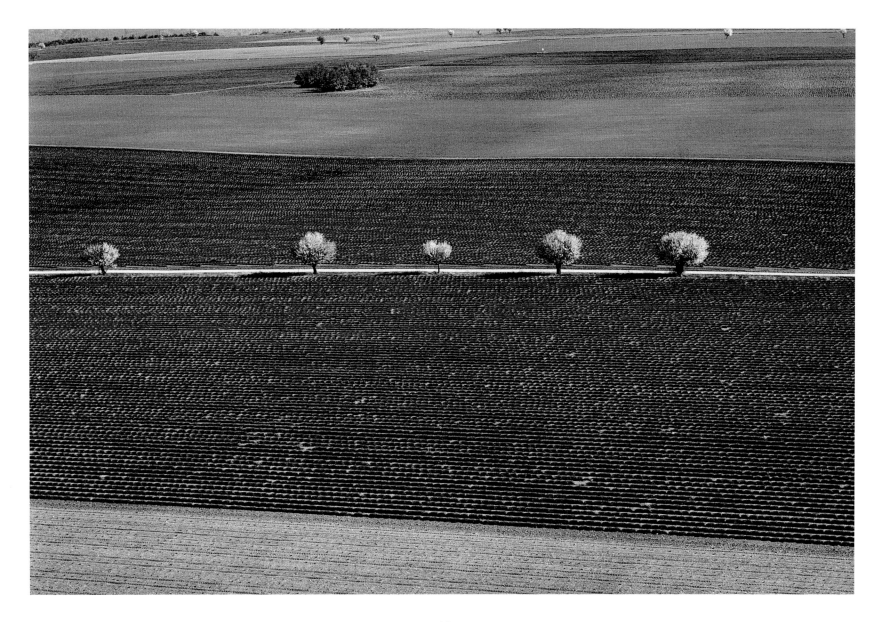

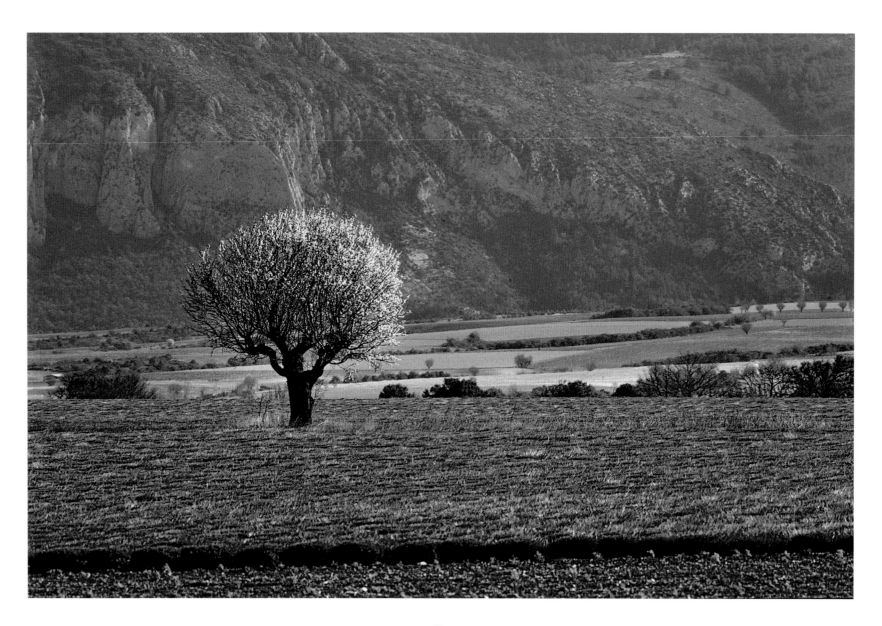

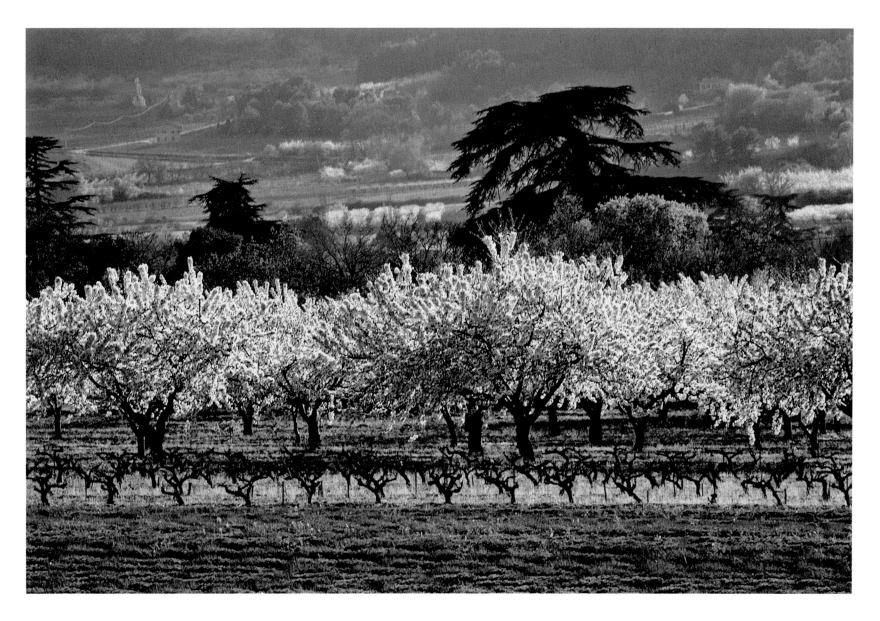

summer

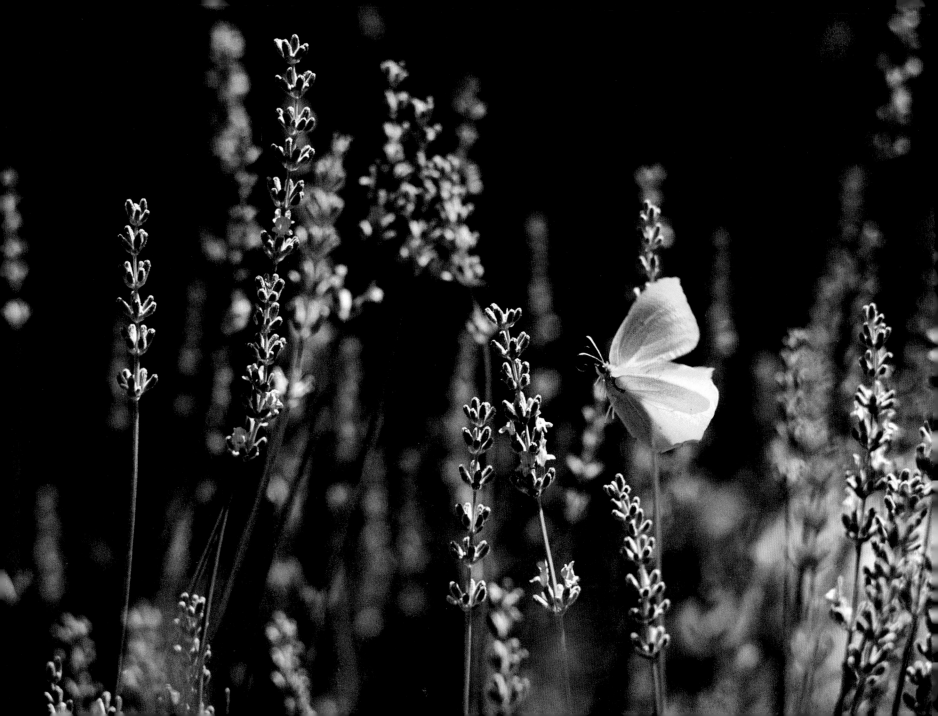

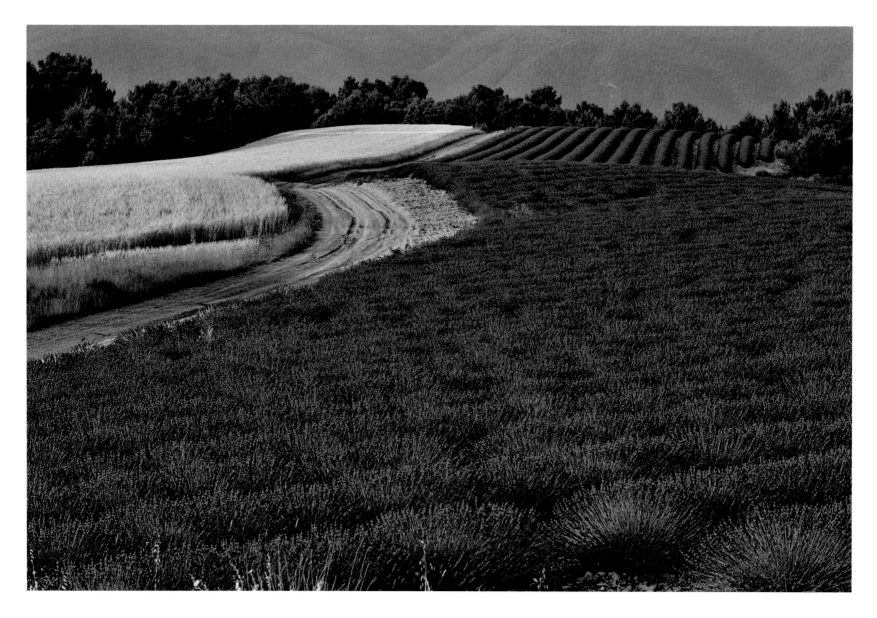

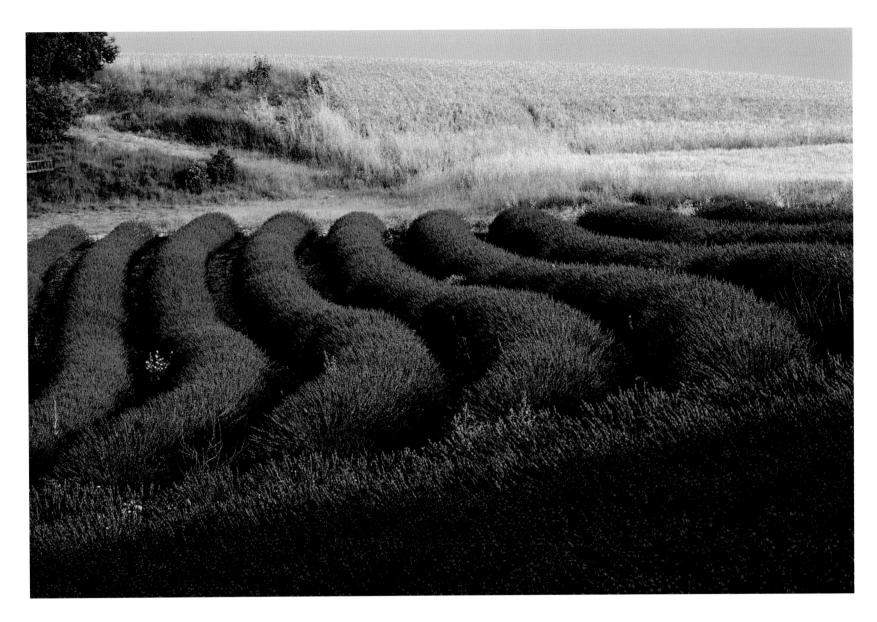

Weeds provide their own magic sparkle among the intense blue of the lavender plants.

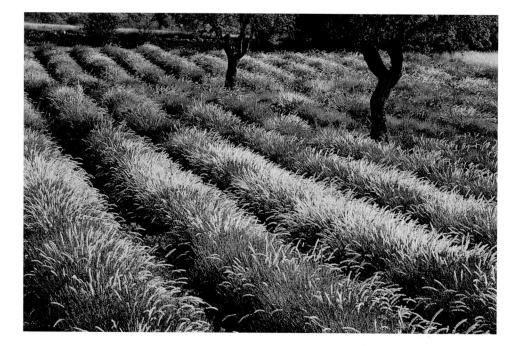

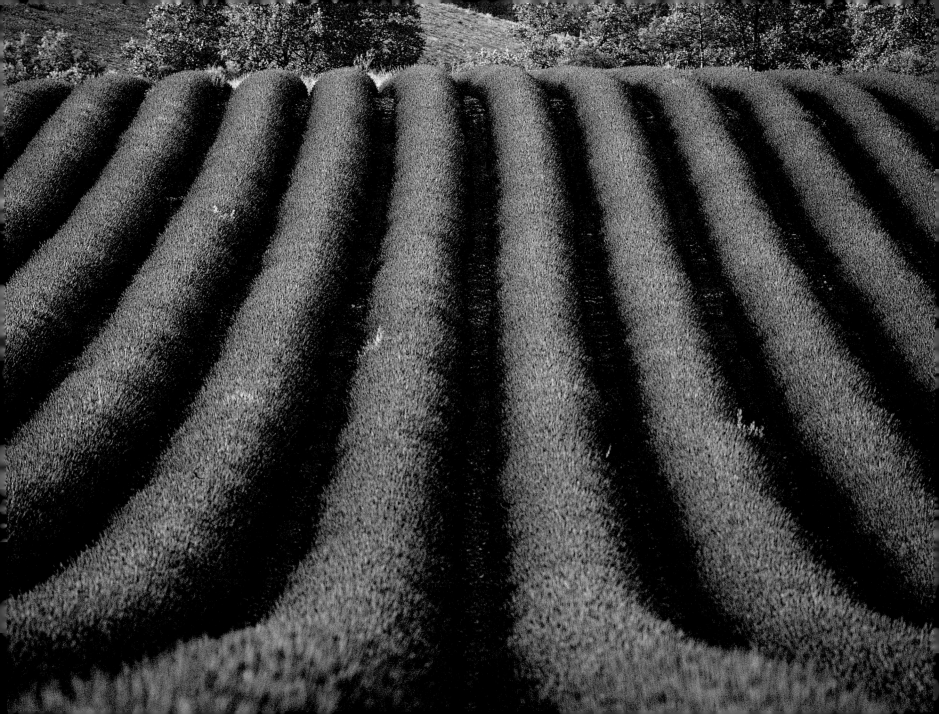

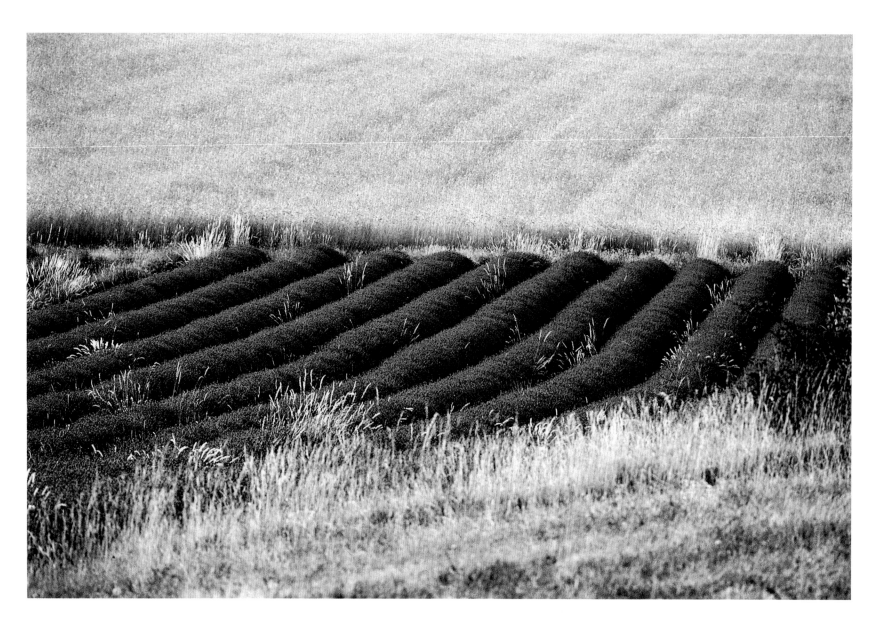

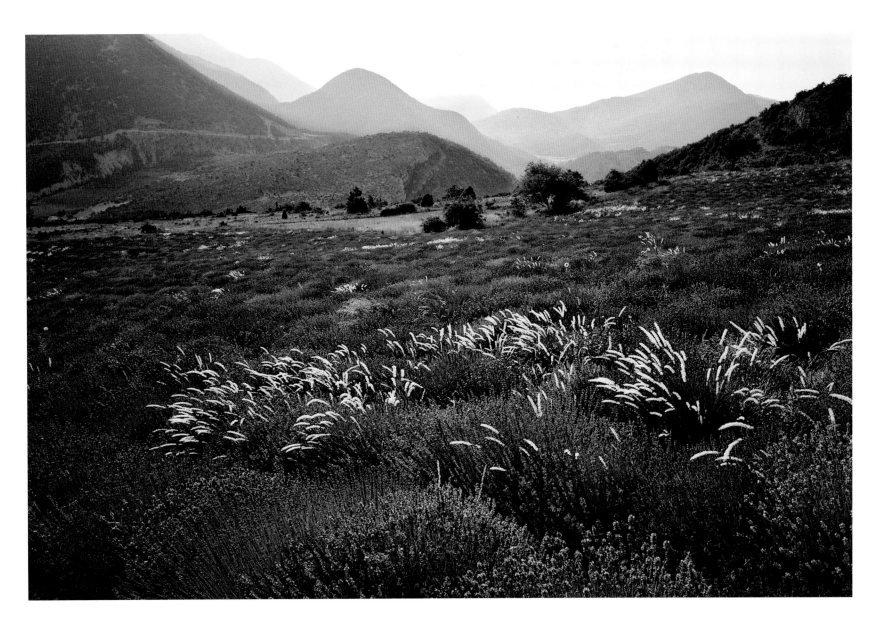

Venerable, impetuous almond trees are scattered like little dots

in a fragrant sea of lavender.

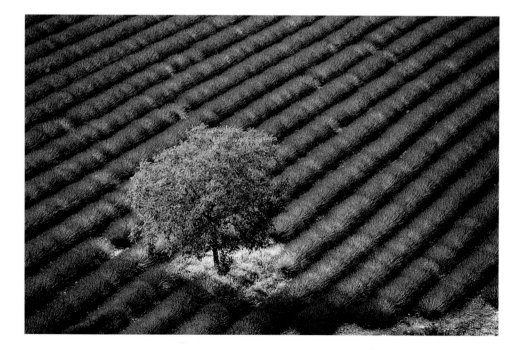

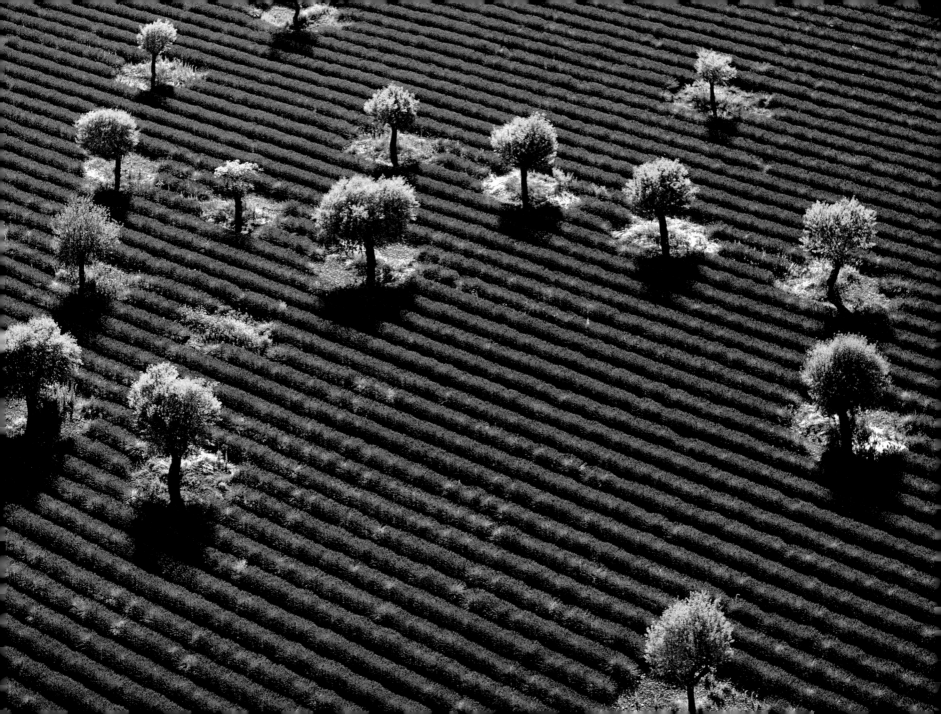

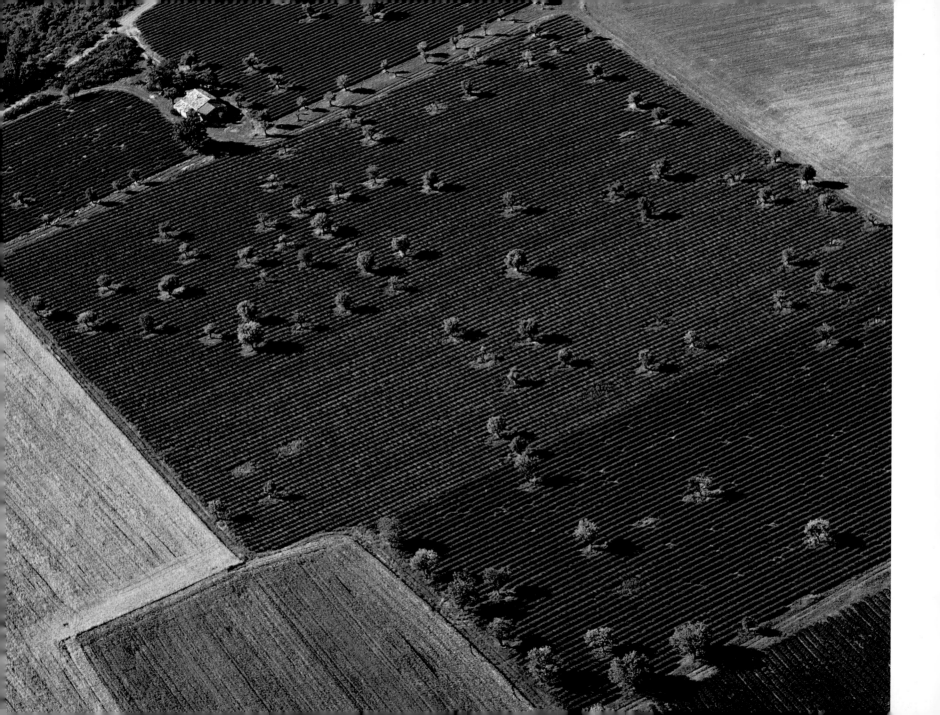

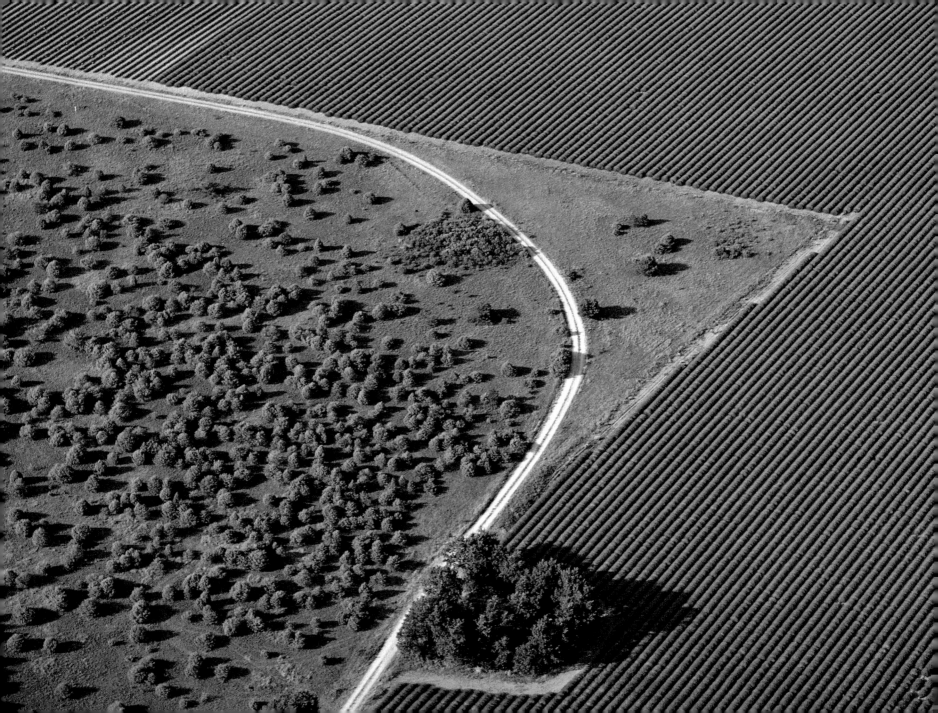

Lavandin fields unfurl their

even rows as far as eye can see.

Under the gentle, colorful wave,

the curves of the rolling hills

can still be discerned. Soon the

plants will become perfume.

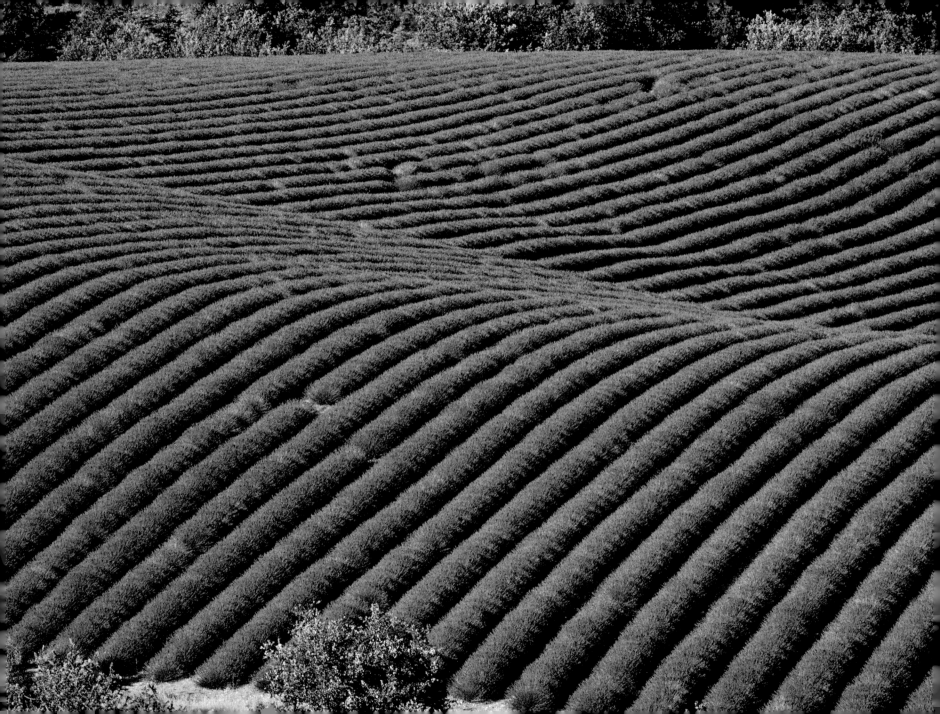

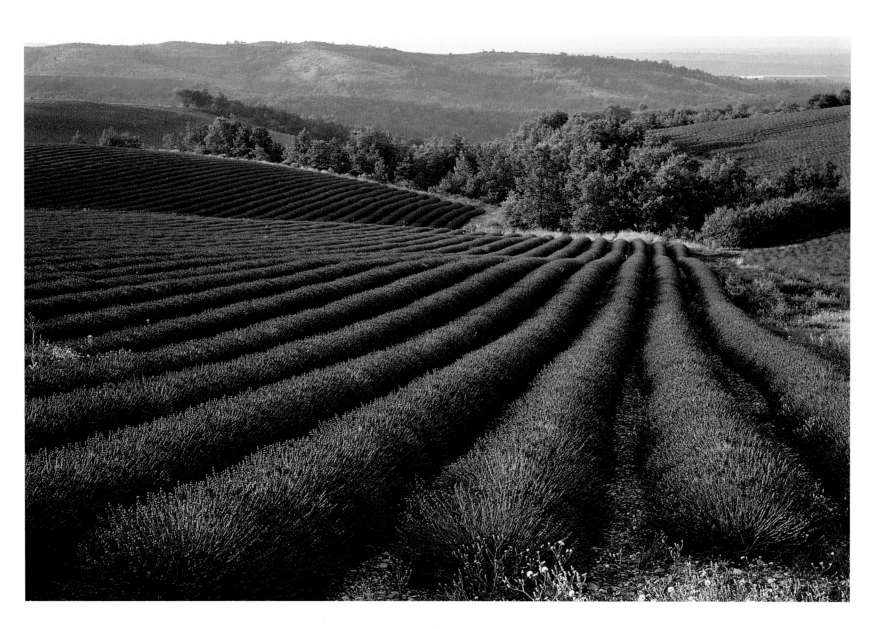

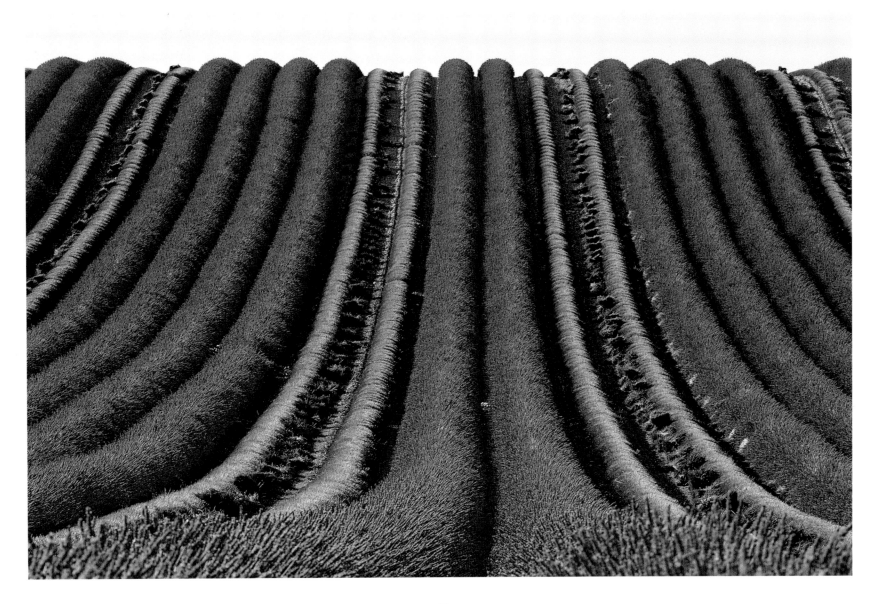

Long ago, this shed held quite a lot of tools and herds passing through.

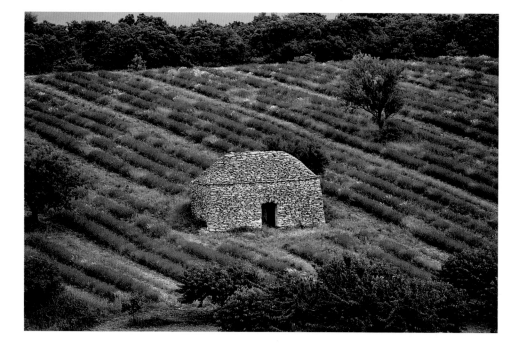

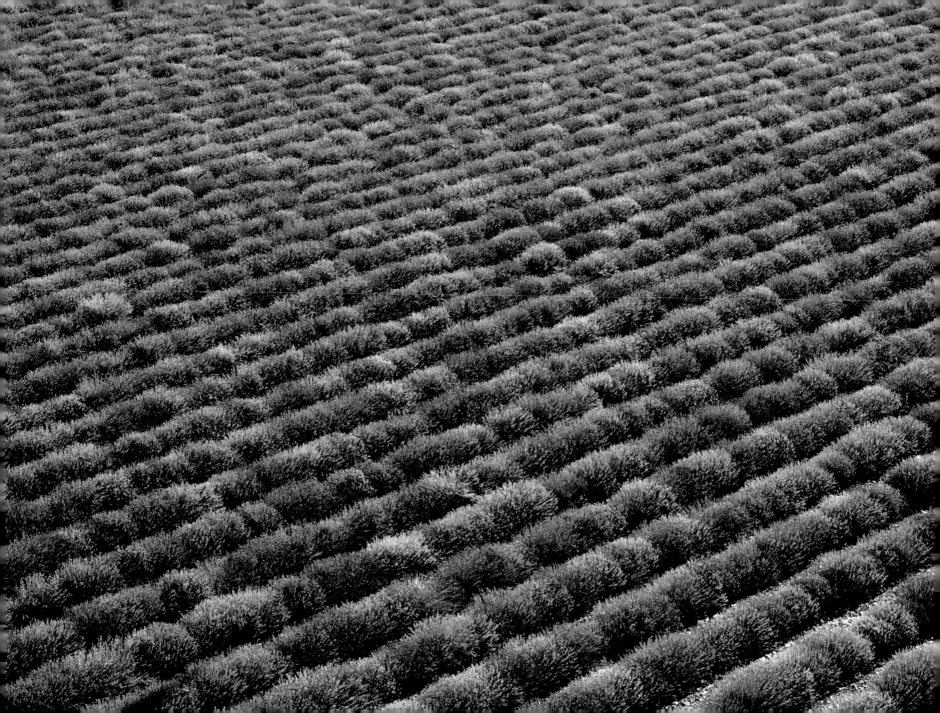

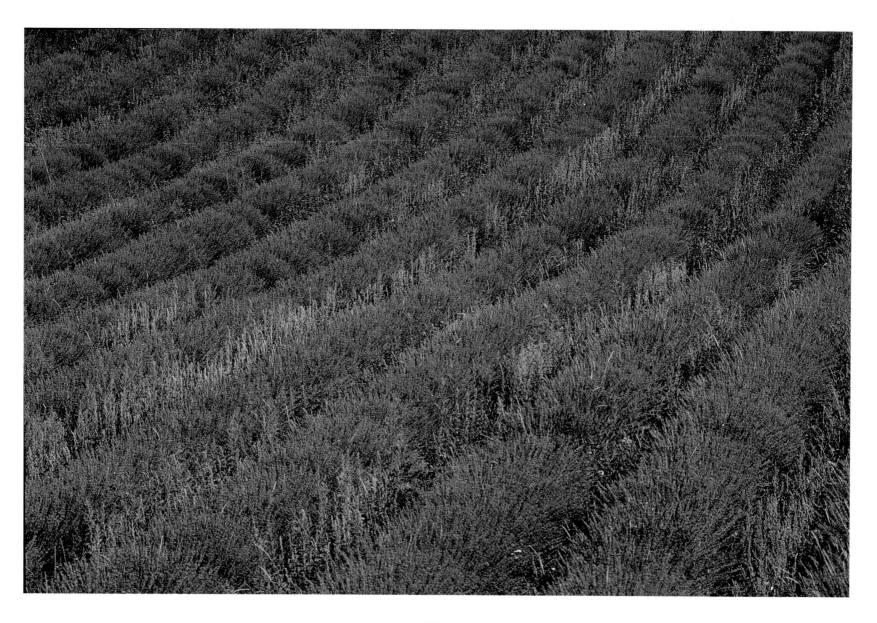

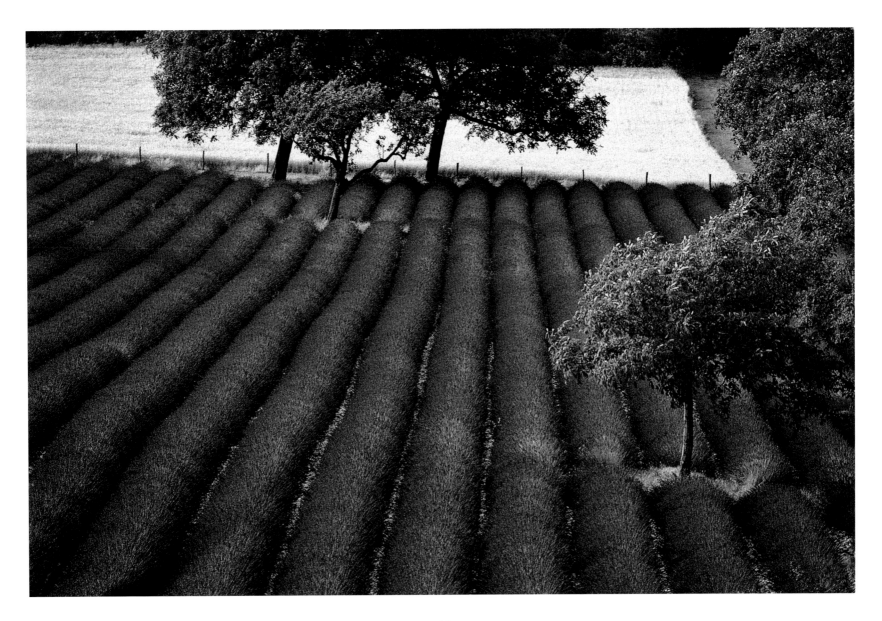

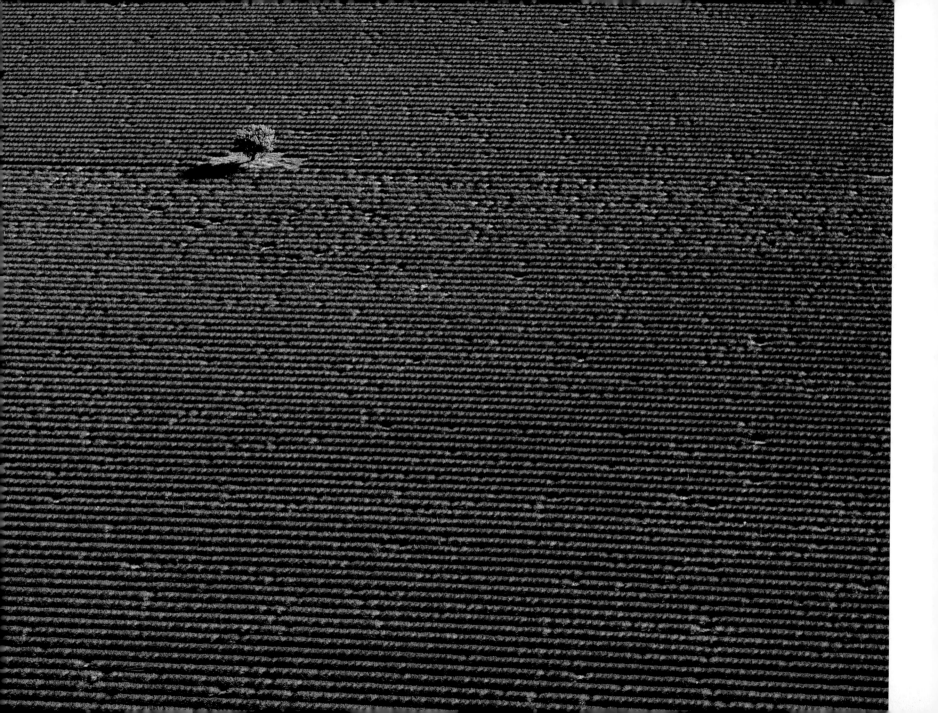

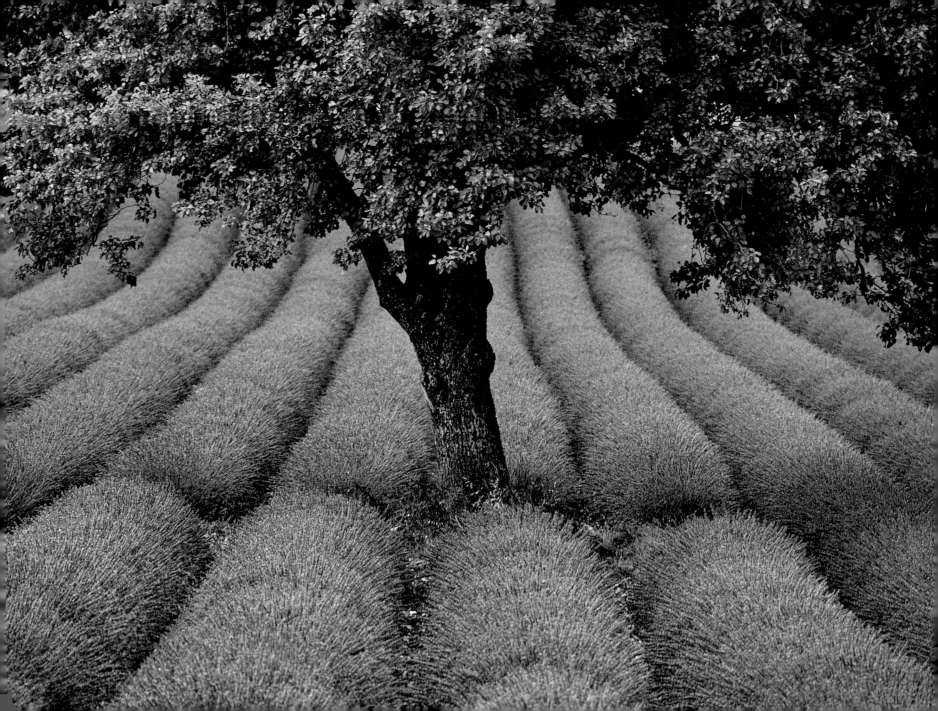

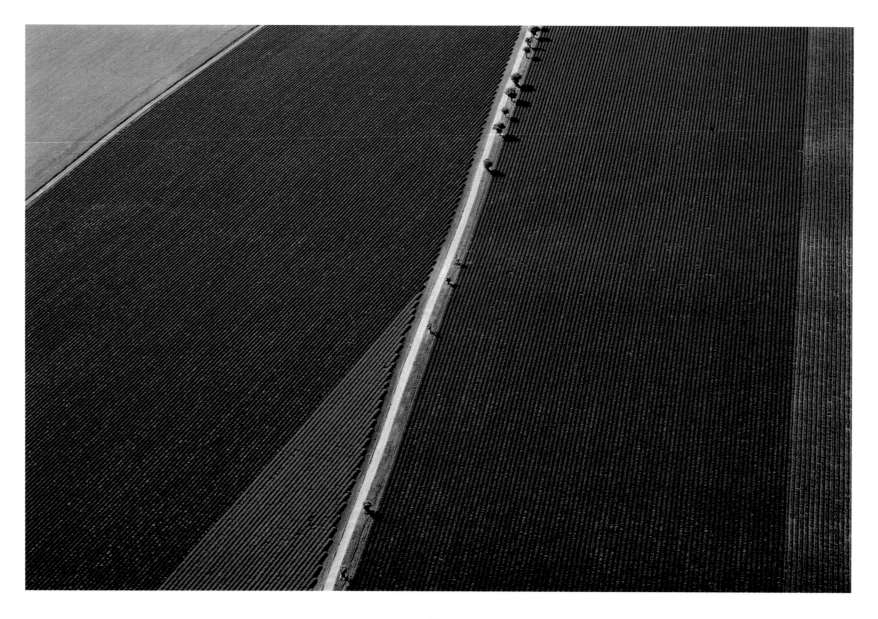

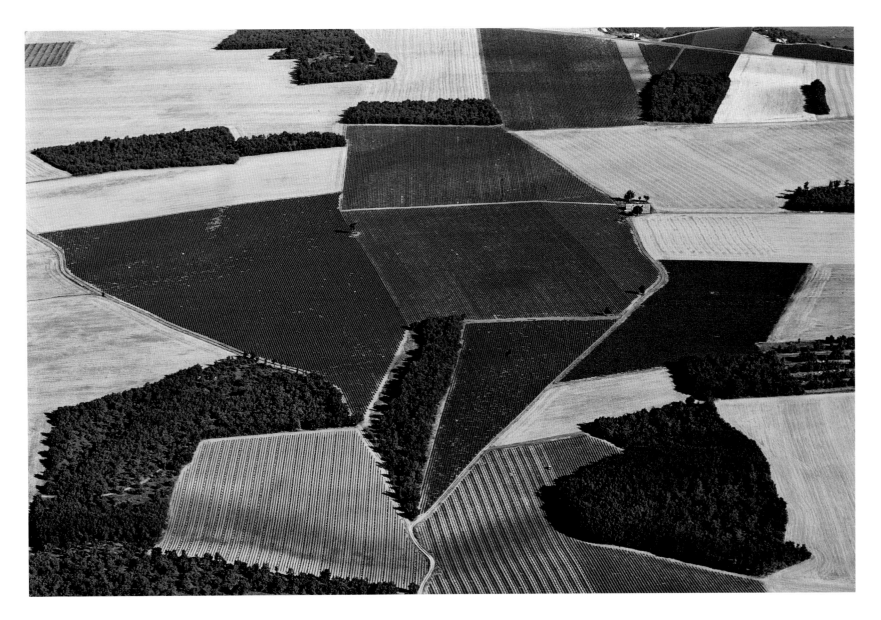

Harvesting is rarely done

by hand. But through time,

the attentive care of man

has established his complicity

with the plant, which in return

offers its marvelous fragrance.

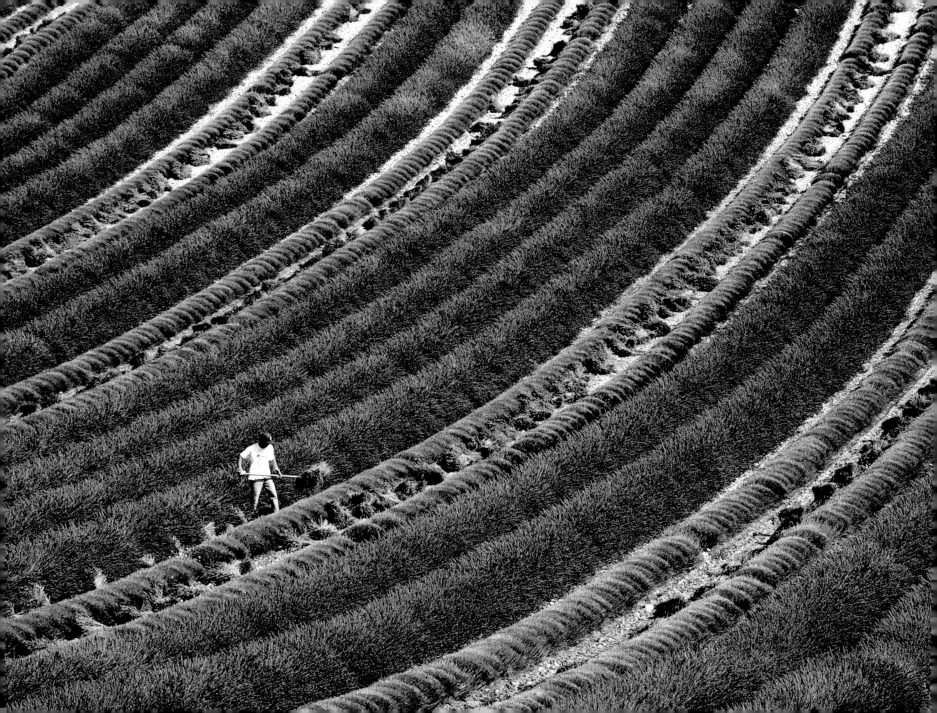

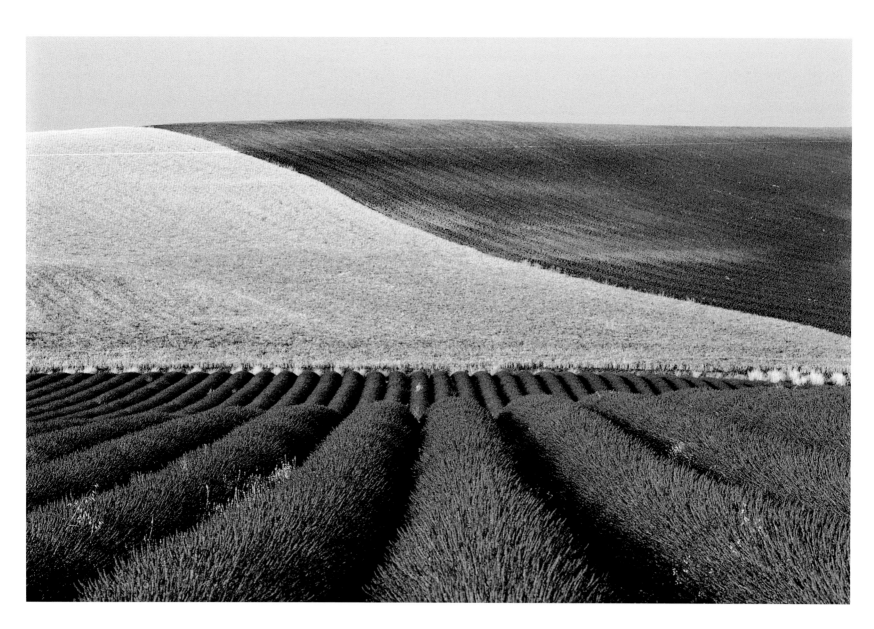

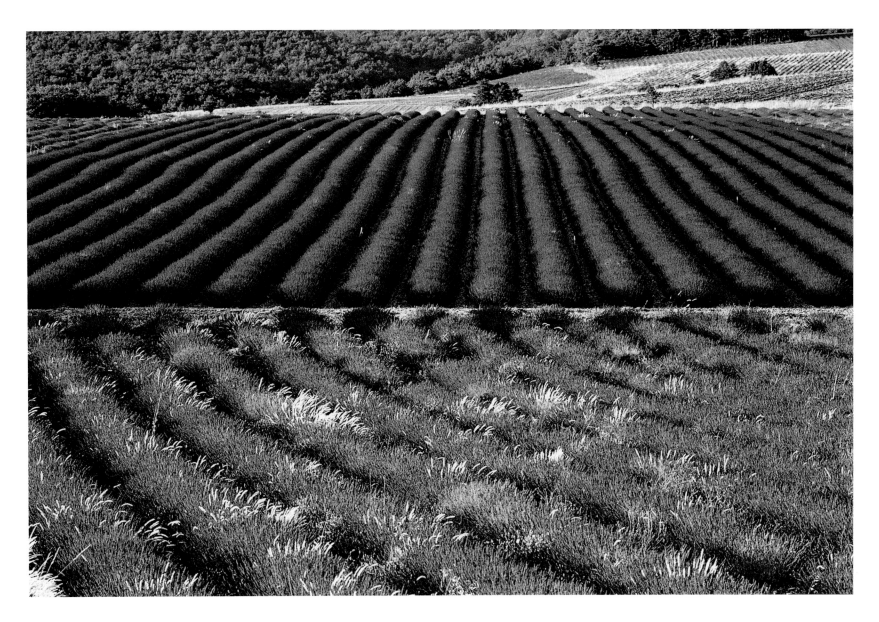

Cut and gathered into tight sheaves, lavender imbues the surrounding area with its strong fragrance before taking the path to the distillery.

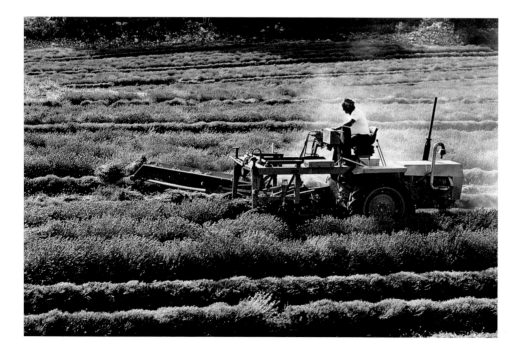

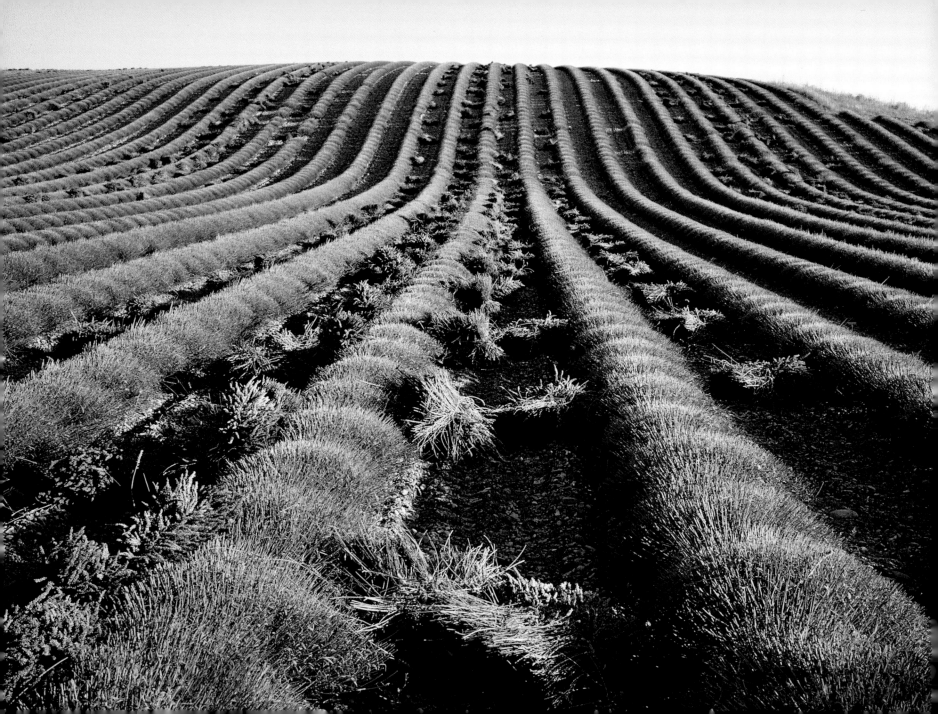

autumn

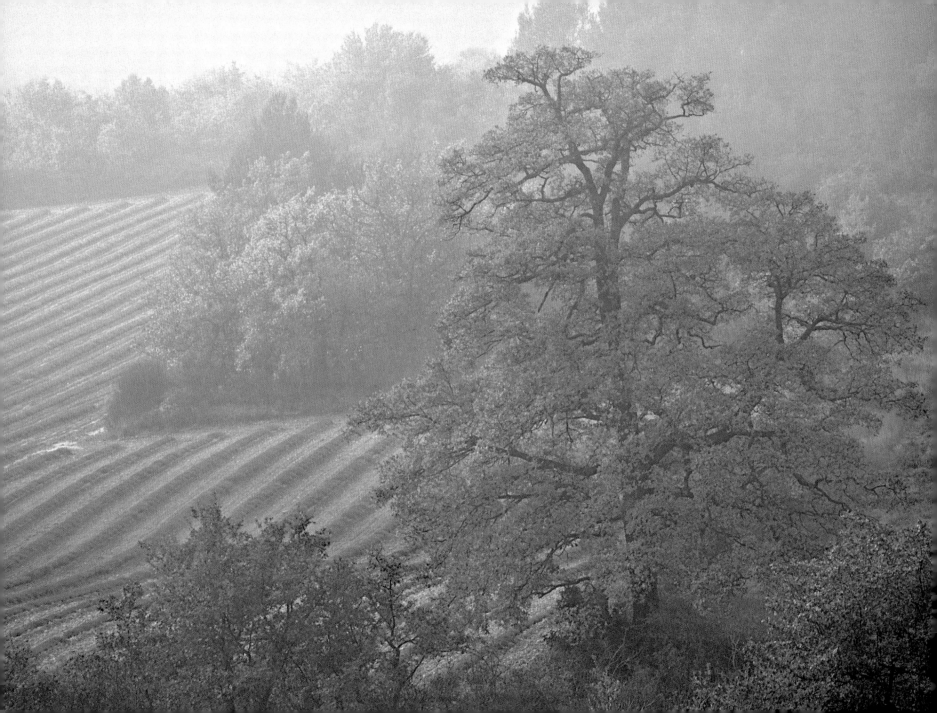

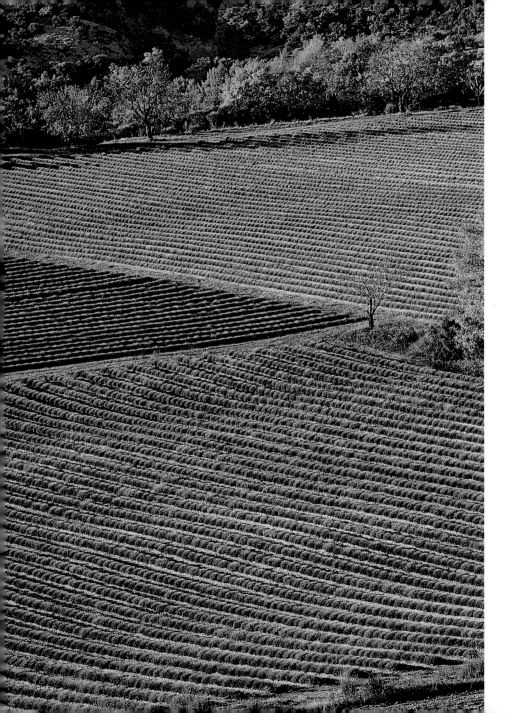

After the flowering season,

the lavender rests.

The branches dry on the plant

and their color deepens

to blend with the autumn hues.

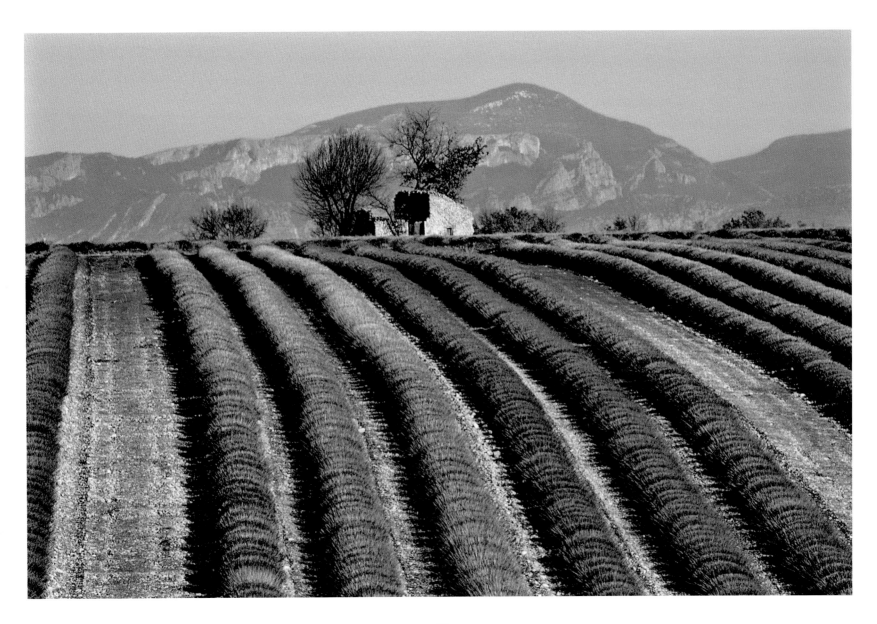

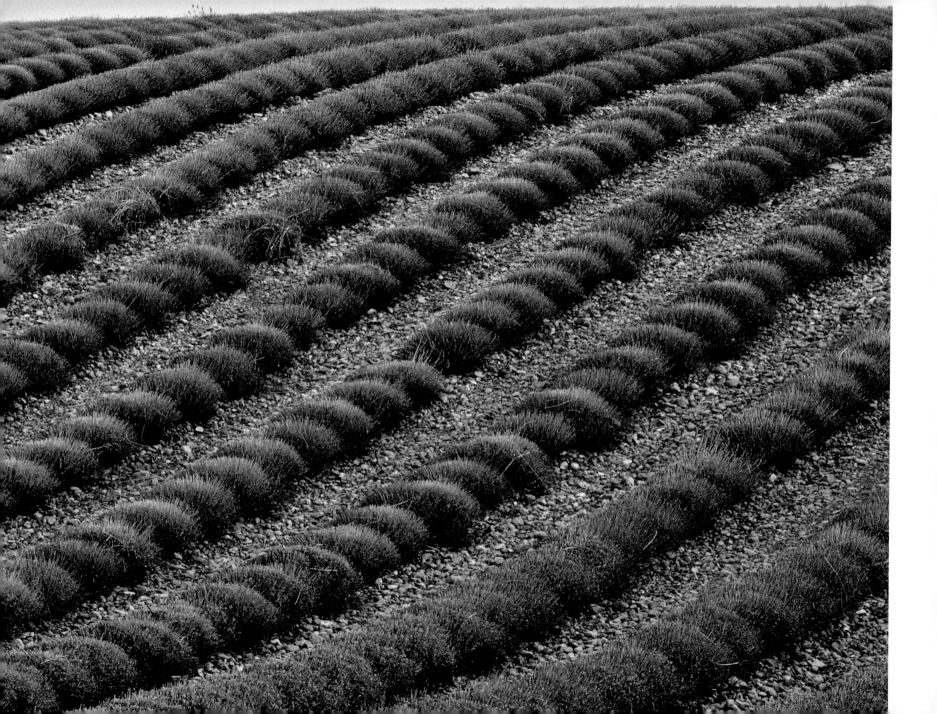

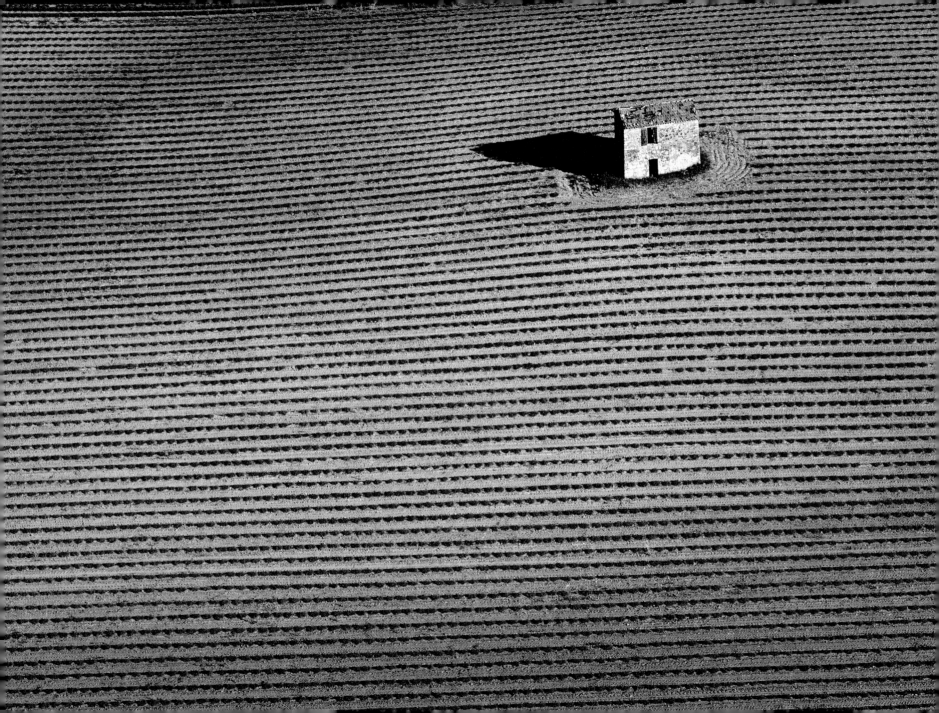

Between its evenly spaced rows,

the lavender accommodates young

oak trees, which one day must

make room for new truffle beds.

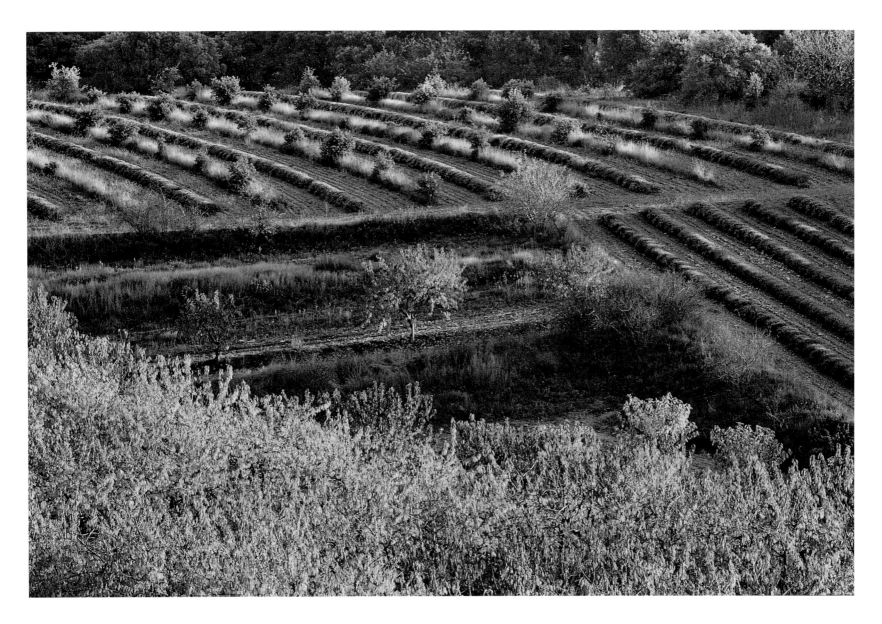

At the foot of Mont Ventoux, poplar trees seem to watch over the fields while they rest.

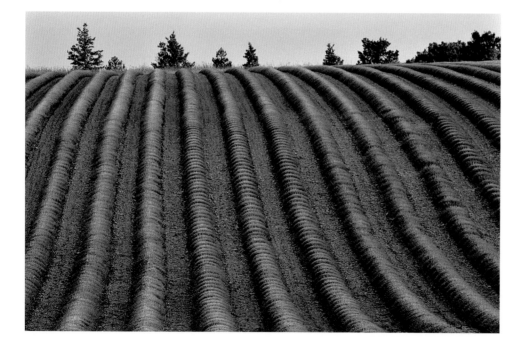

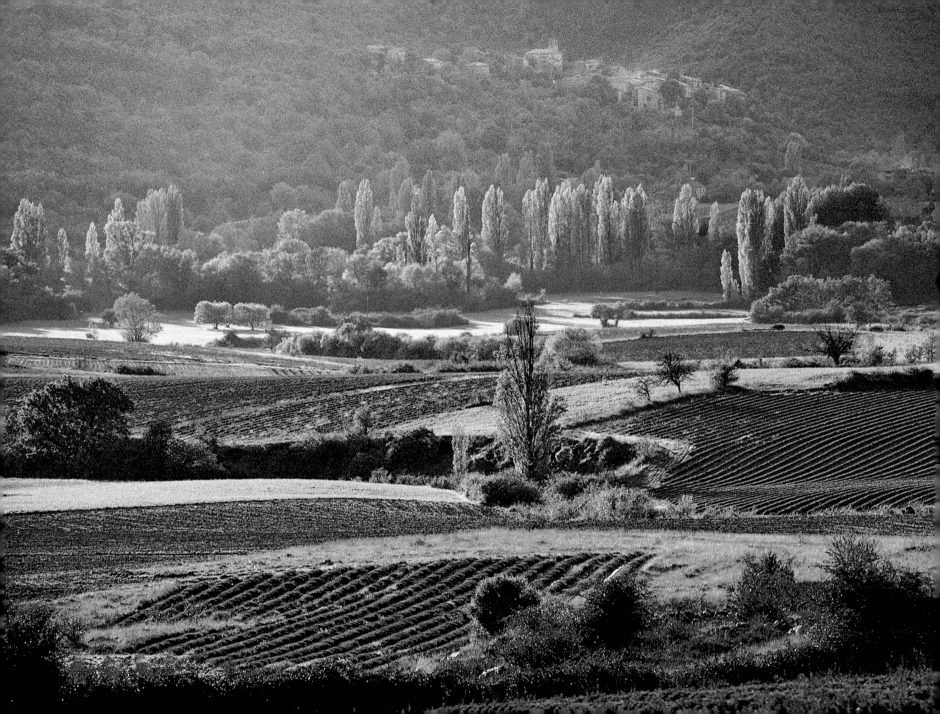

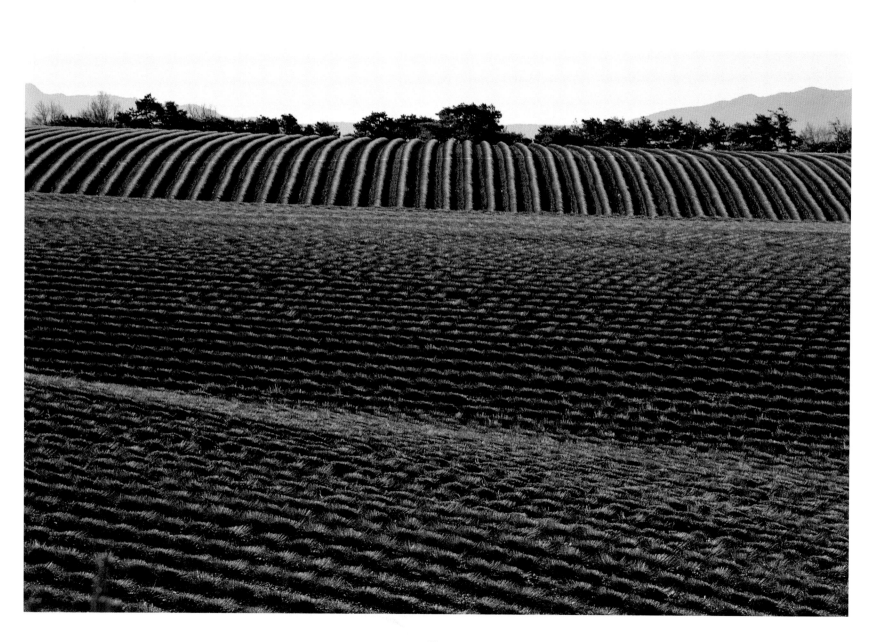

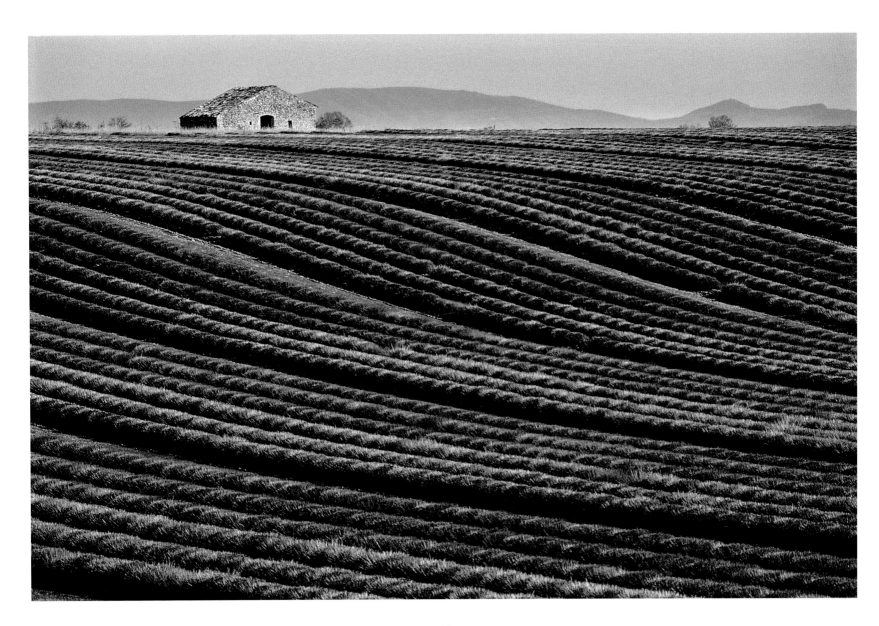

91

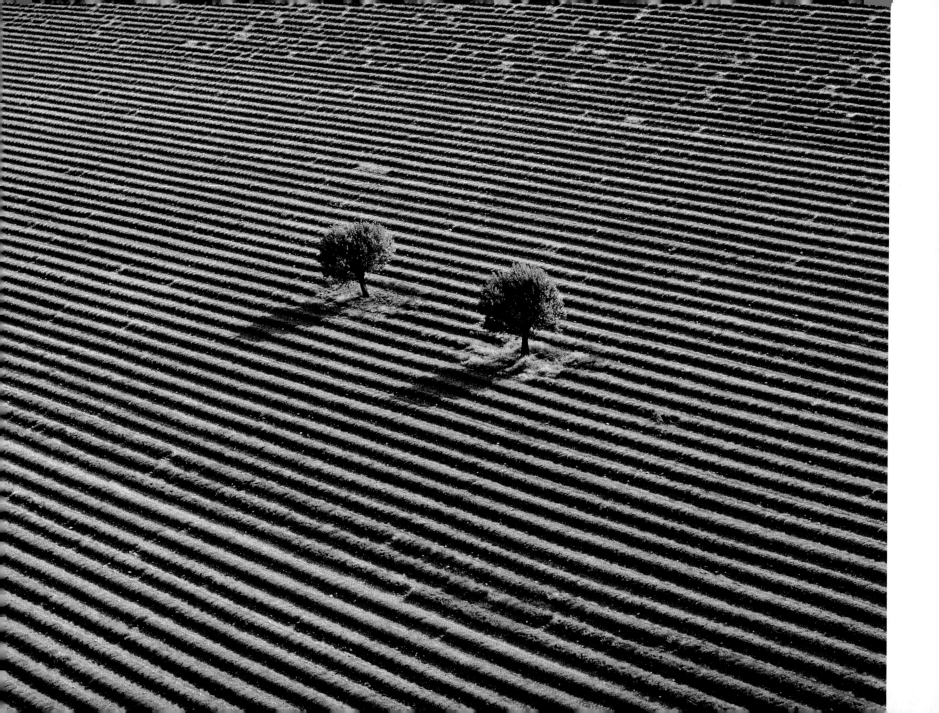

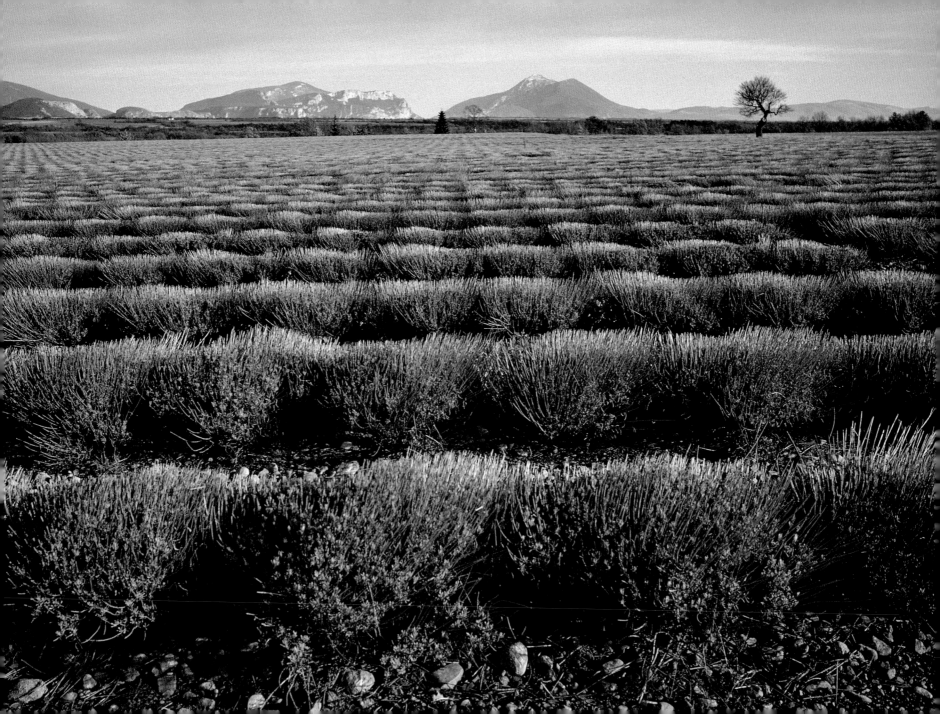

Lavender is not afraid of rocks nor the sheep who, oblivious to its charms,

cross right over it en route to other fields.

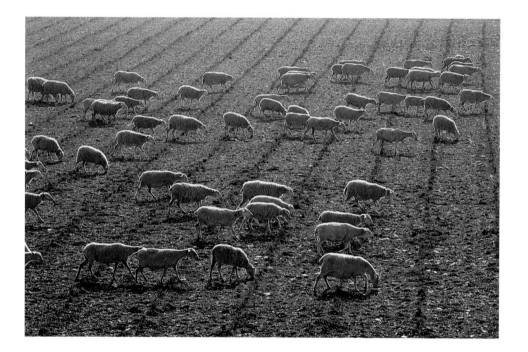

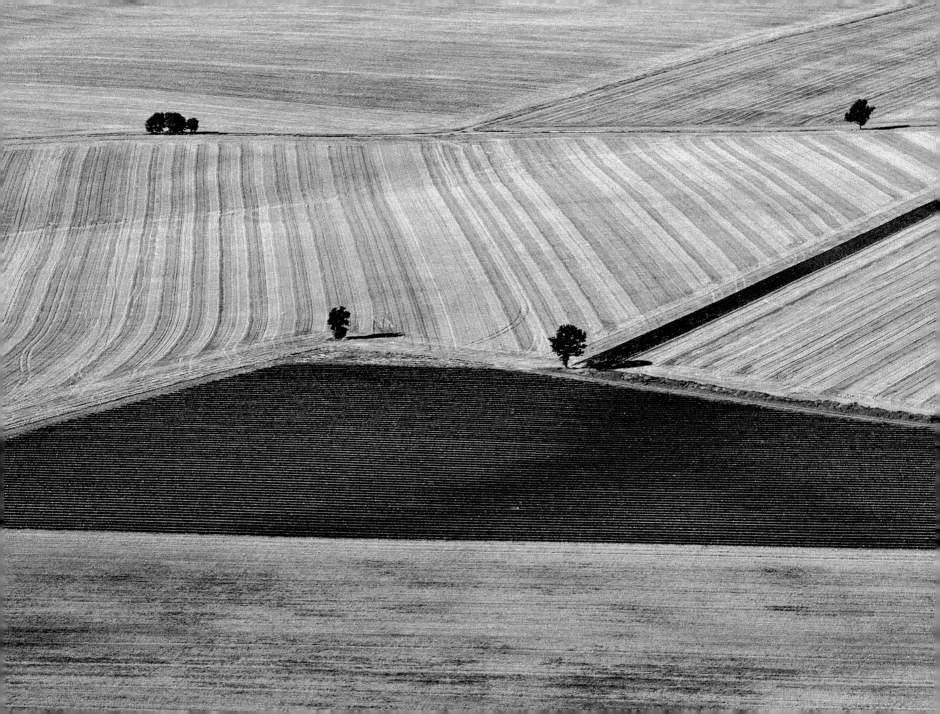

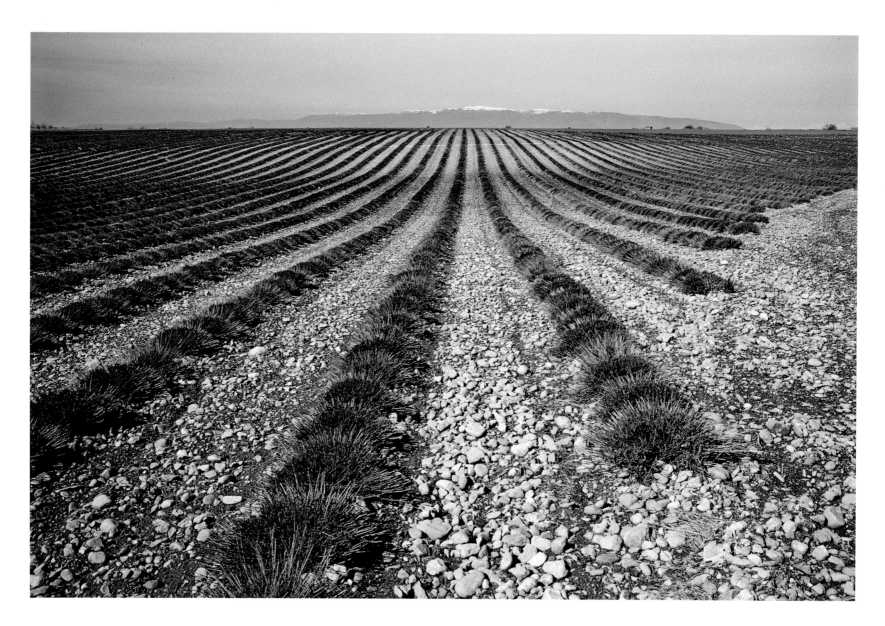

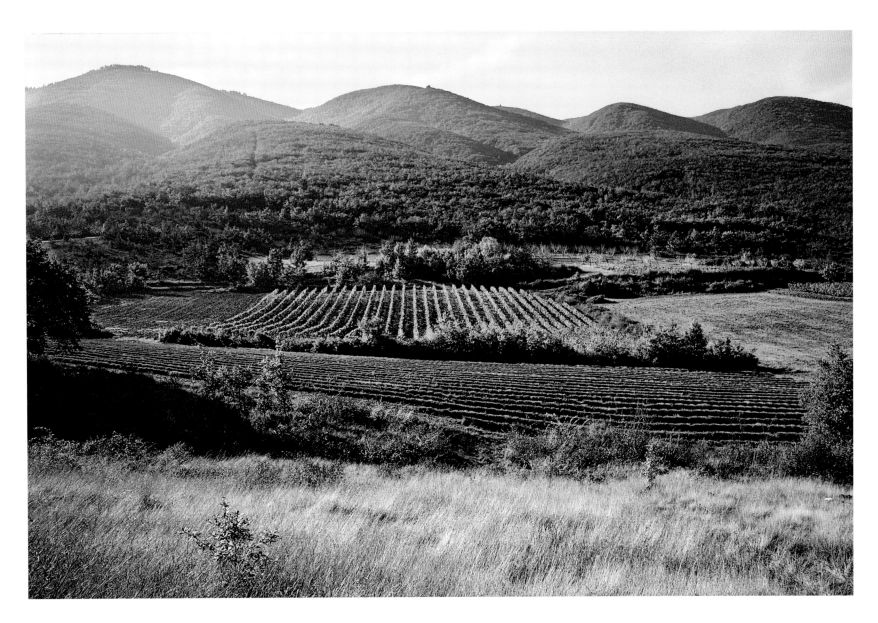

If there are no young plants, a simple twig stuck in the soil will naturally take root.

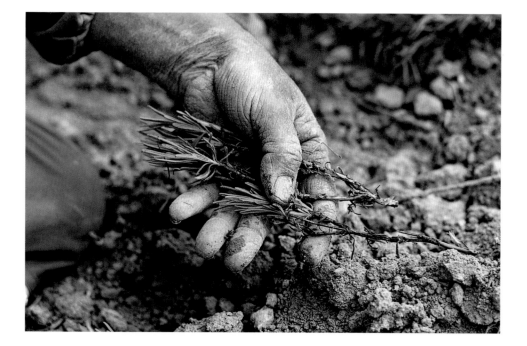

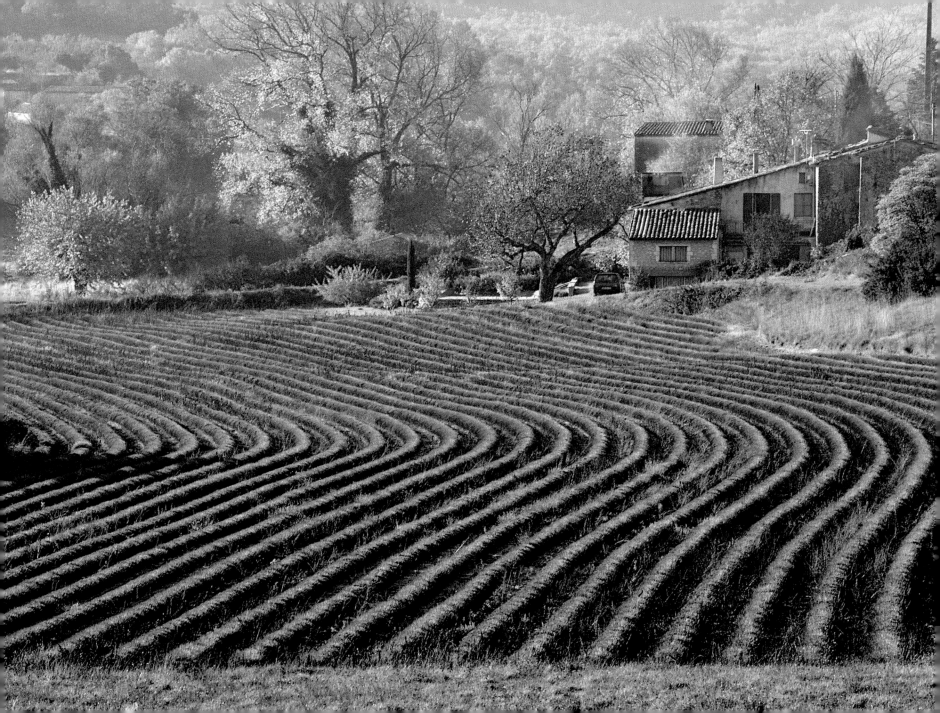

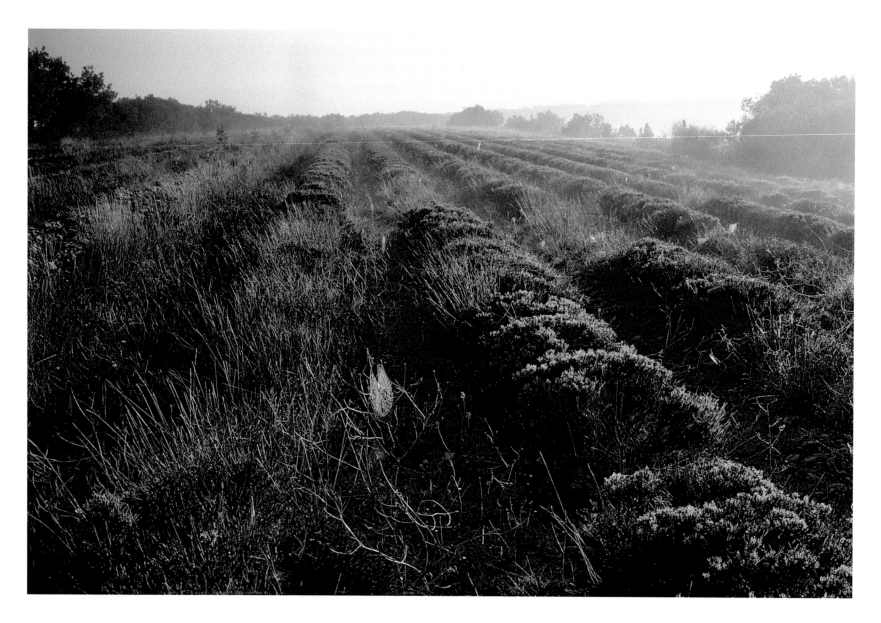

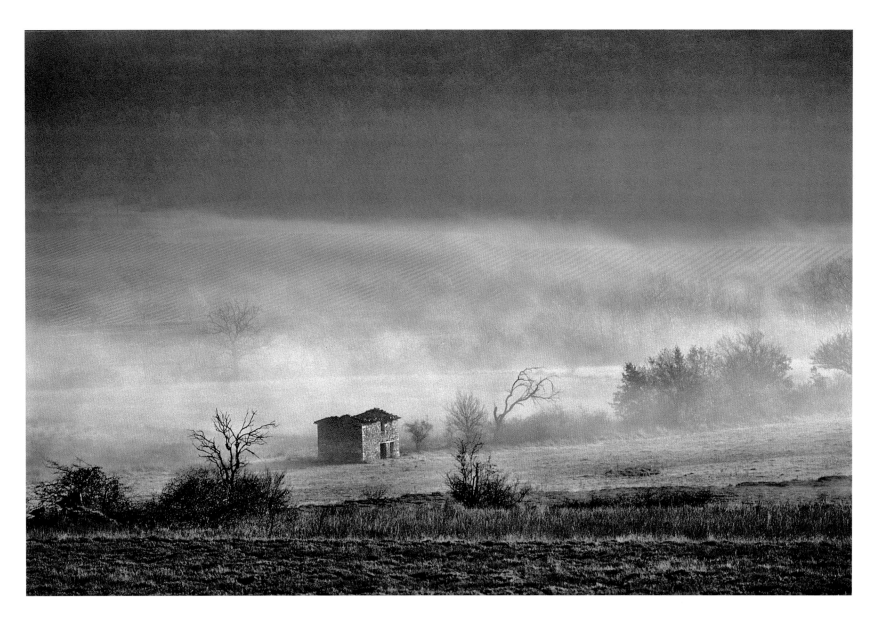

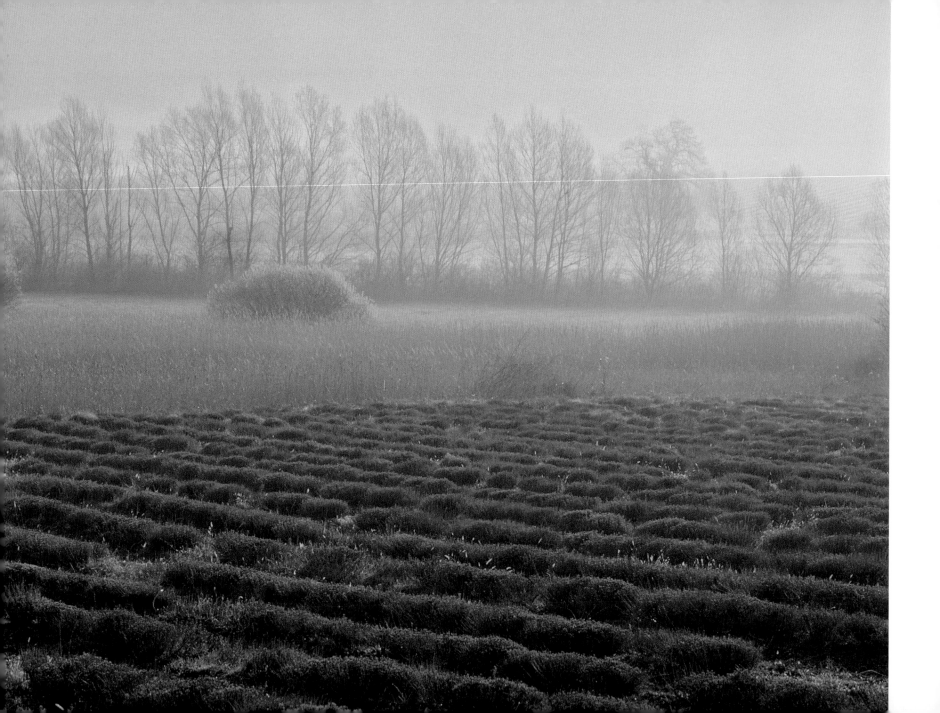

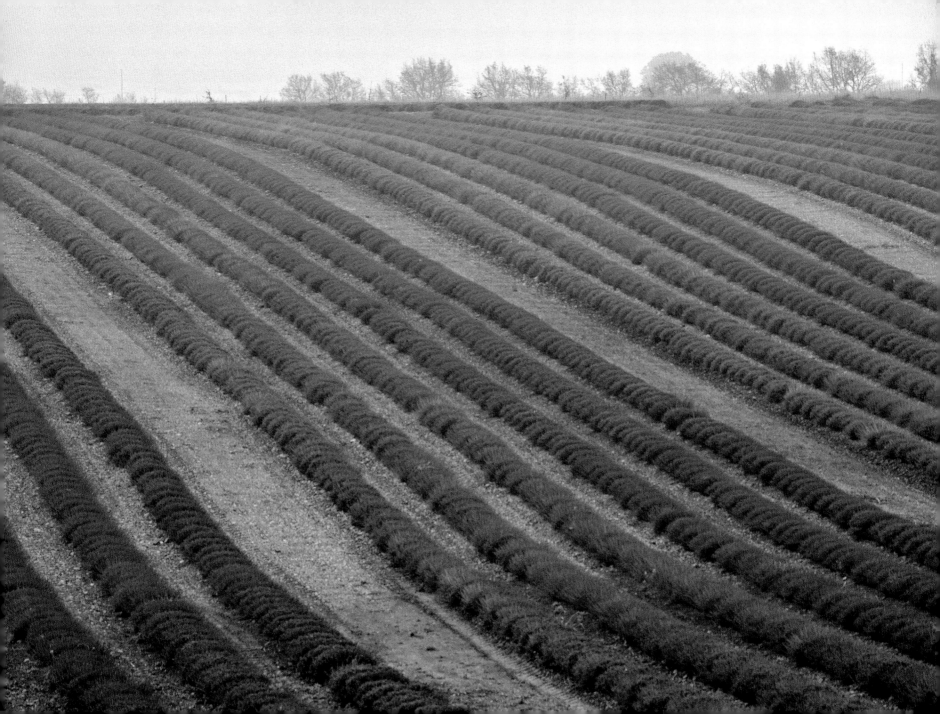

Though Provence's worst enemy,

fire is sometimes used to clean up

the borders around the fields.

This time-honored technique

requires a know-how that has been

passed down through generations.

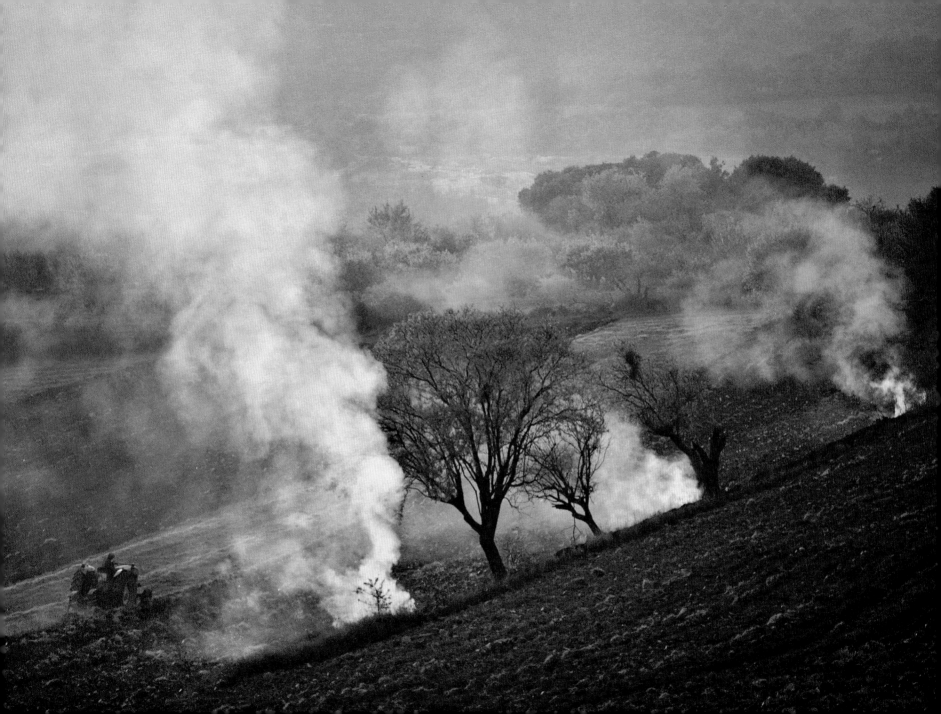

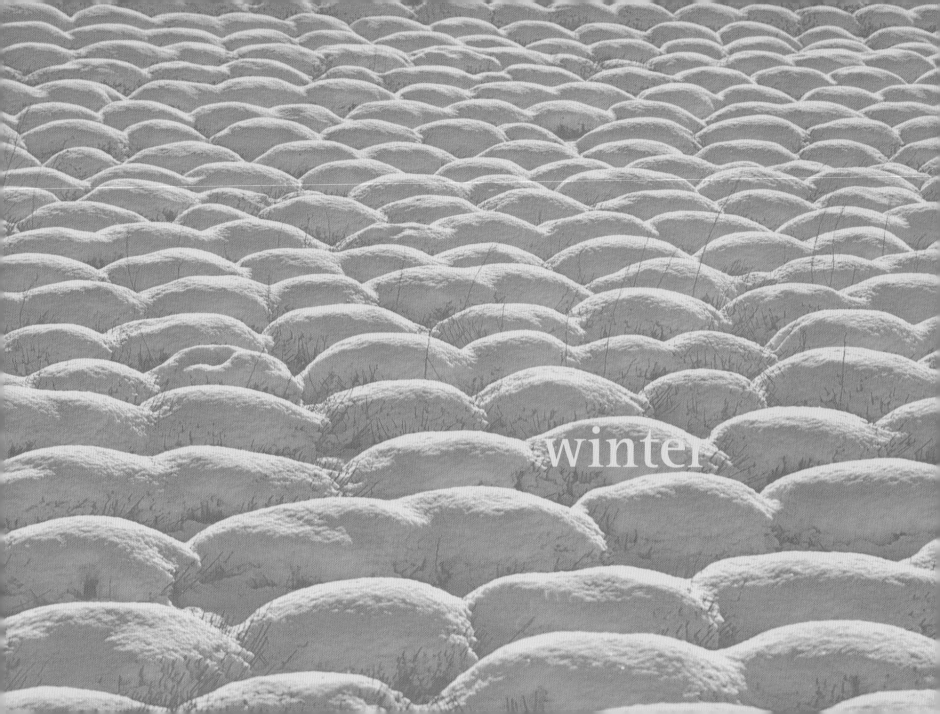

winter

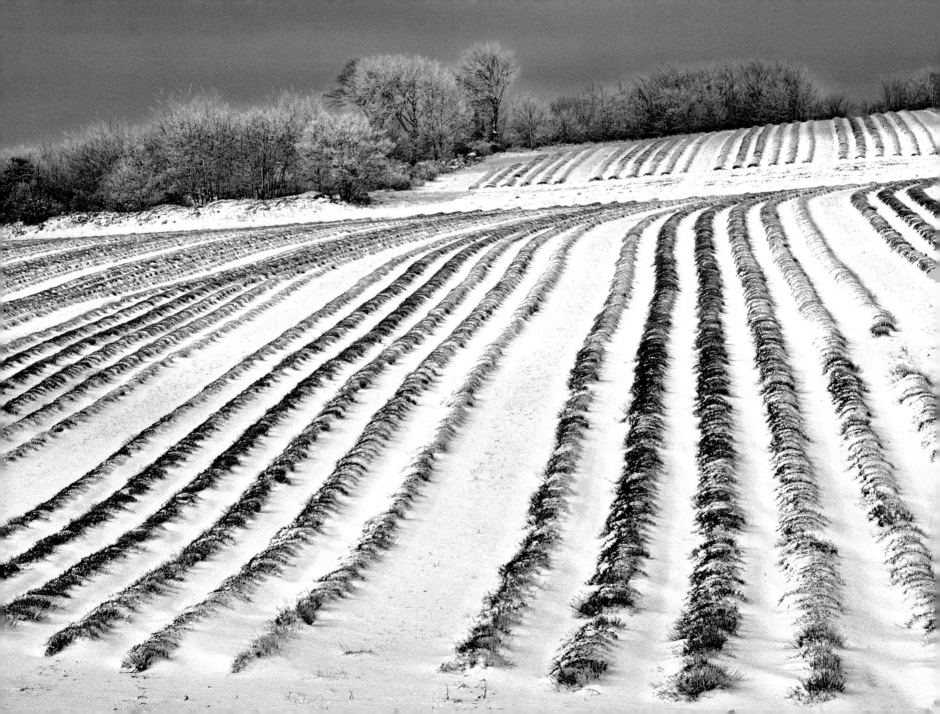

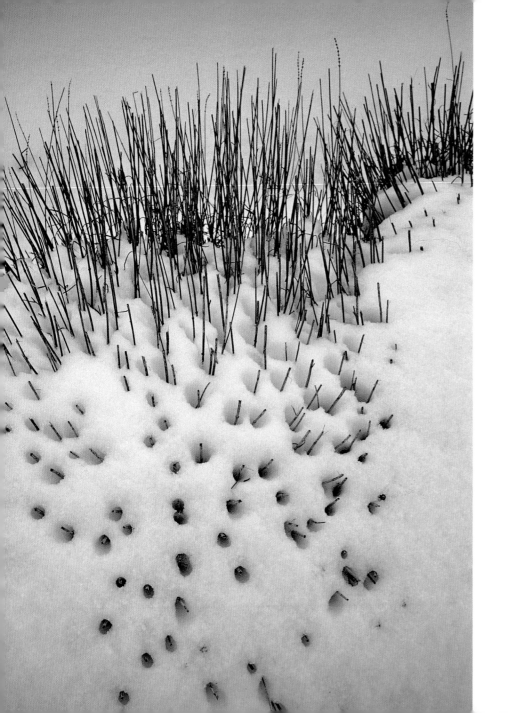

Even in this sun-drenched land it does snow in the mountainous regions during winter. Indifferent to the intense cold, the lavender huddles under the white, shimmering blanket of snow.

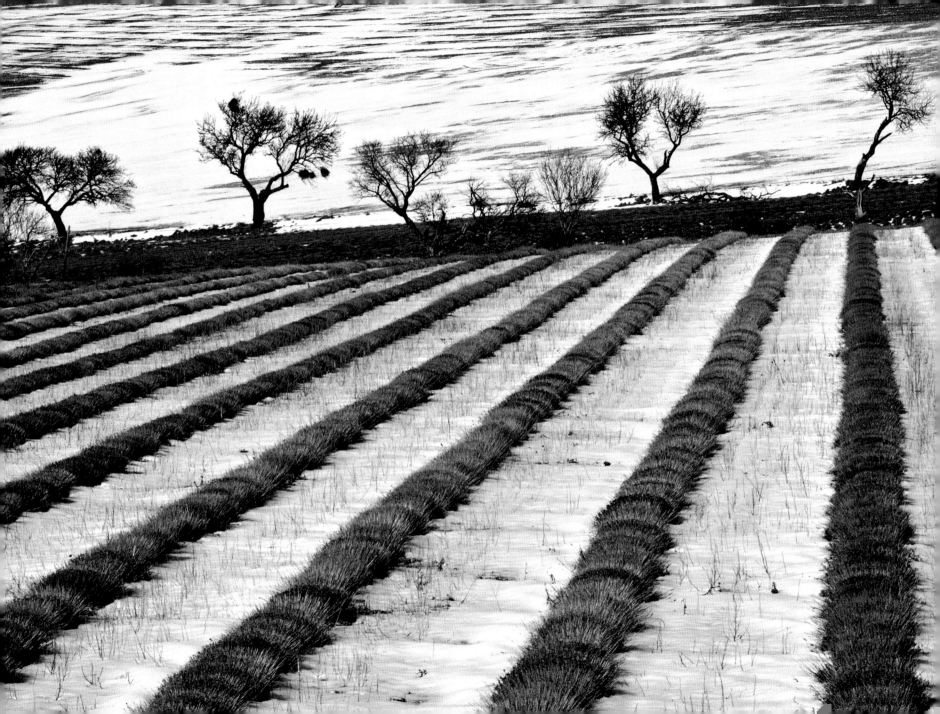

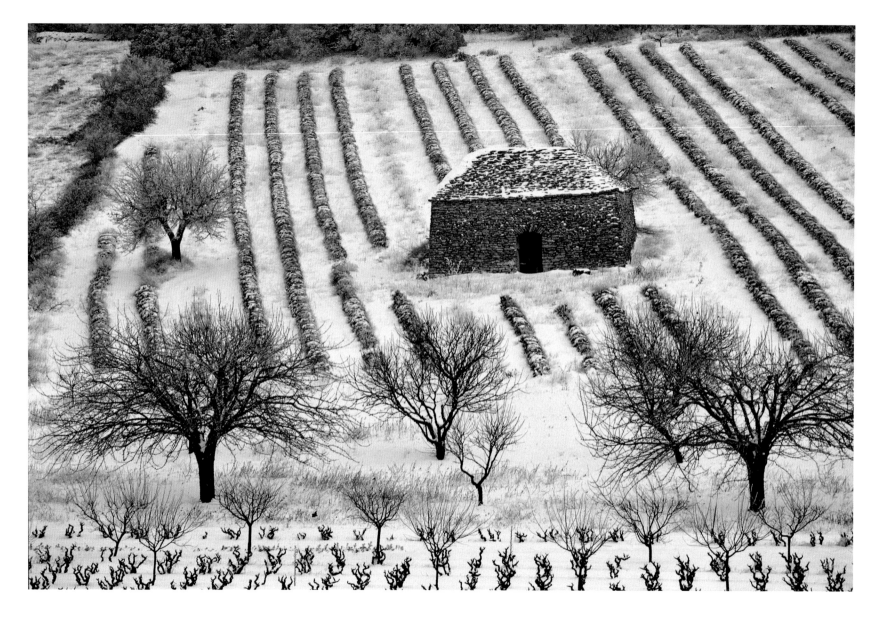

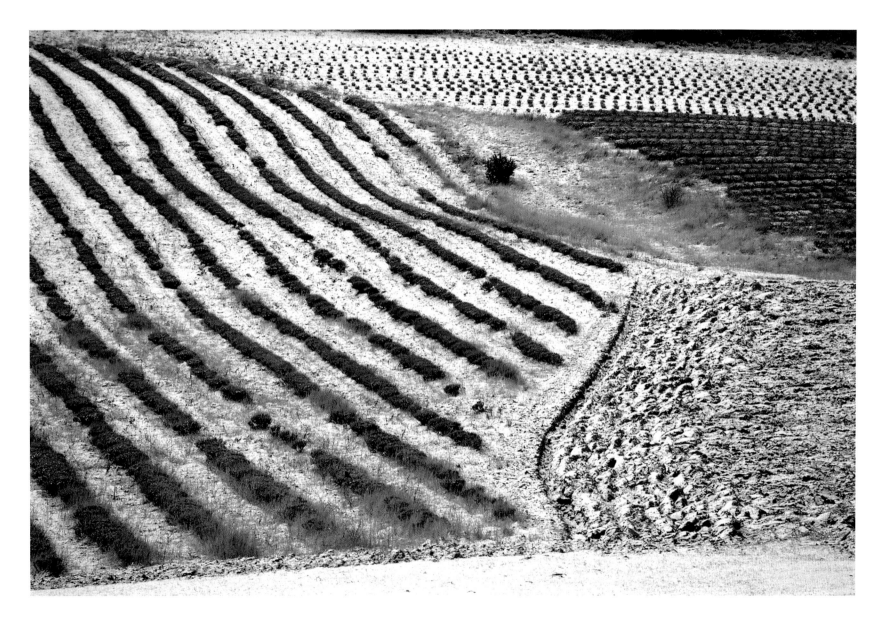

Punctuating the landscape with their delicate lines, the mixture of vines, cherry trees, lavender, and evergreen oaks evoke the richness of the land.

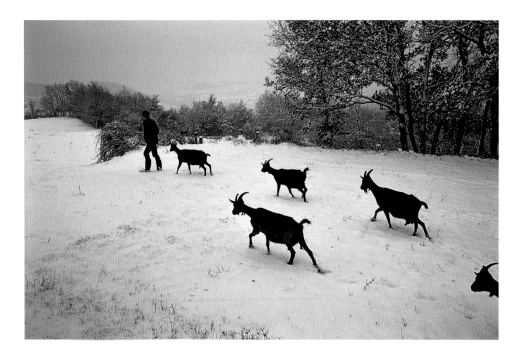

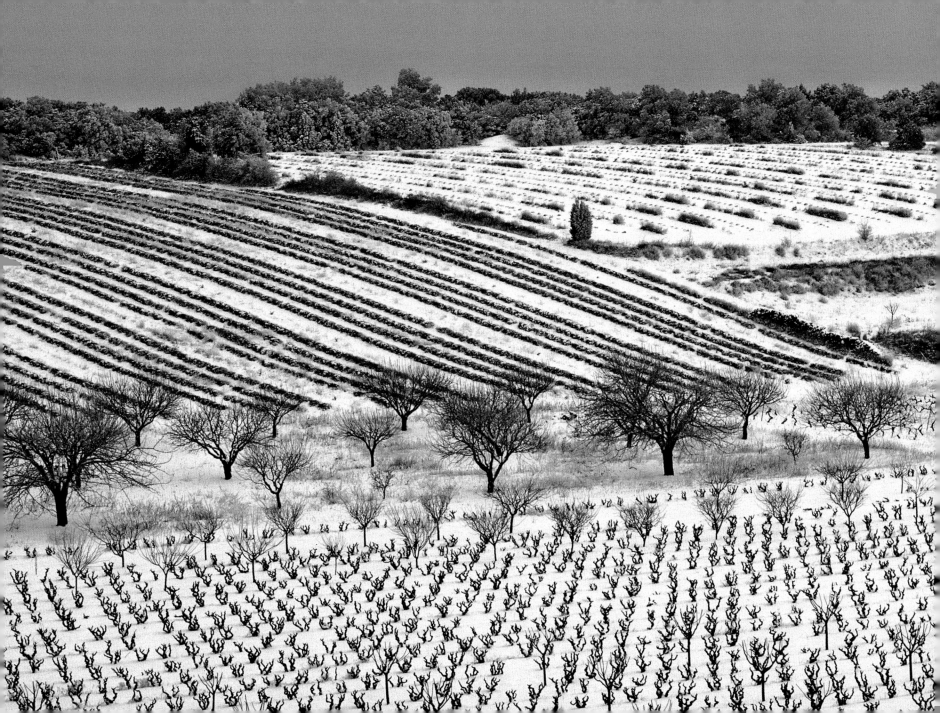

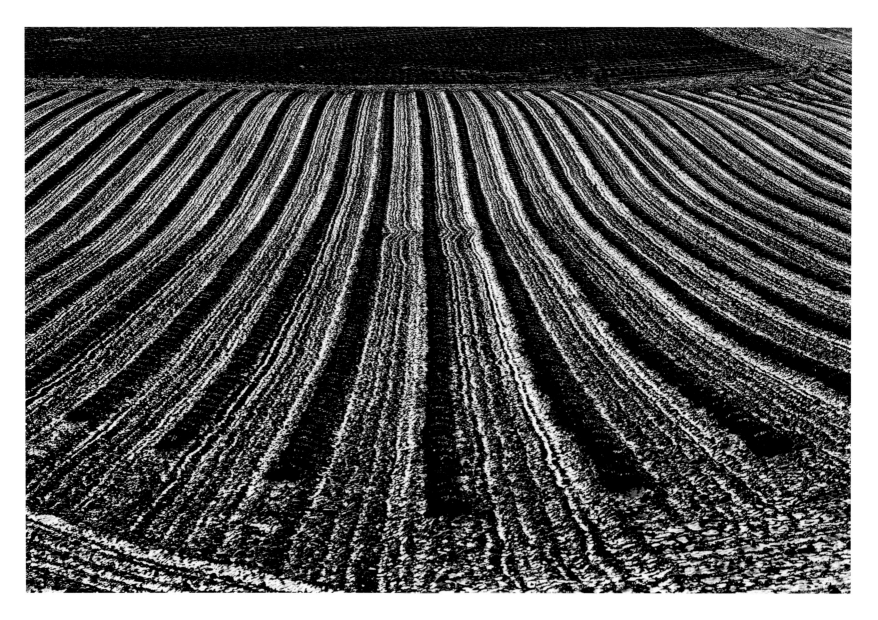

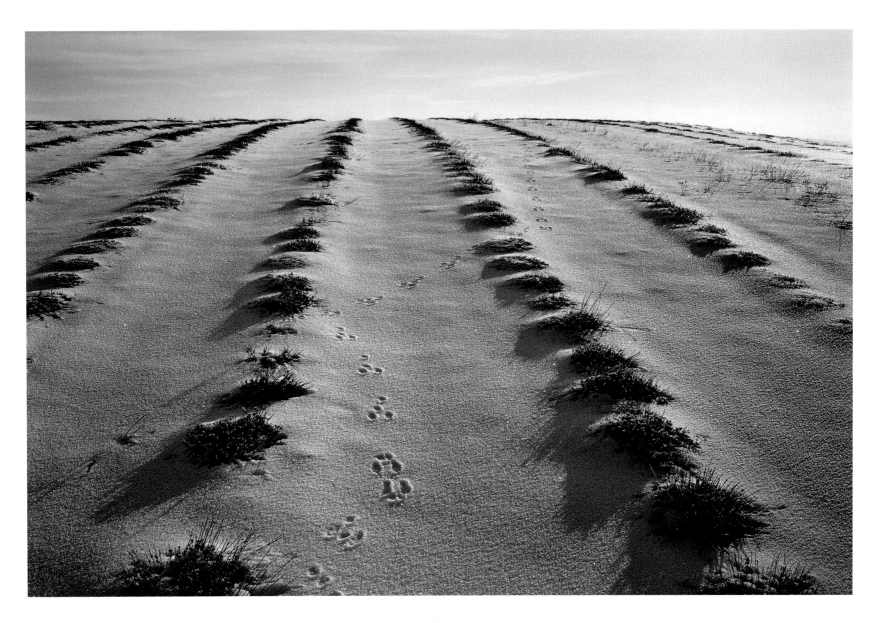

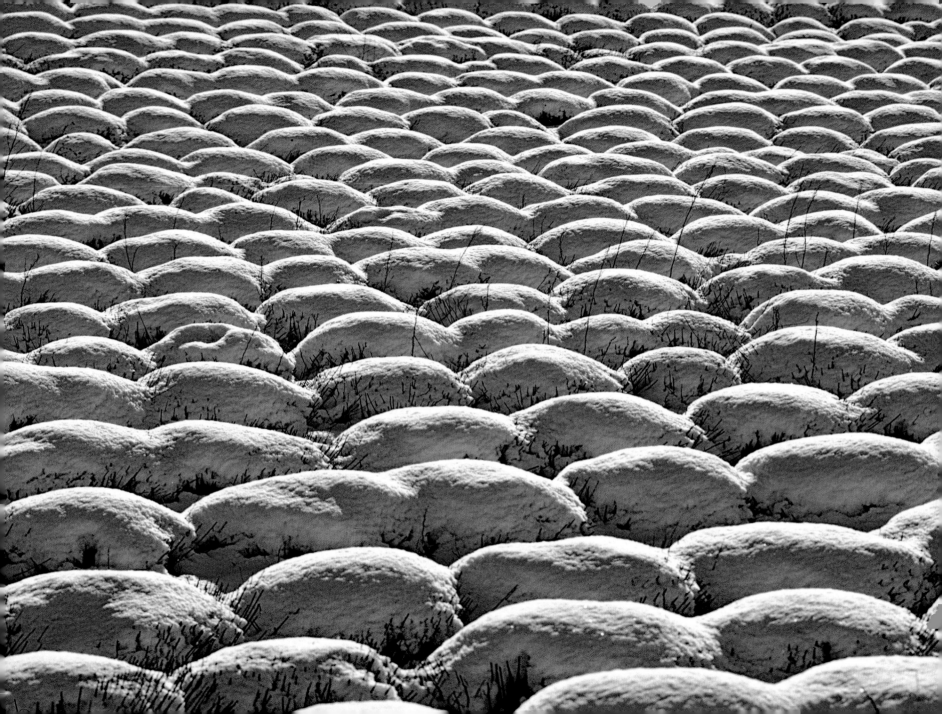

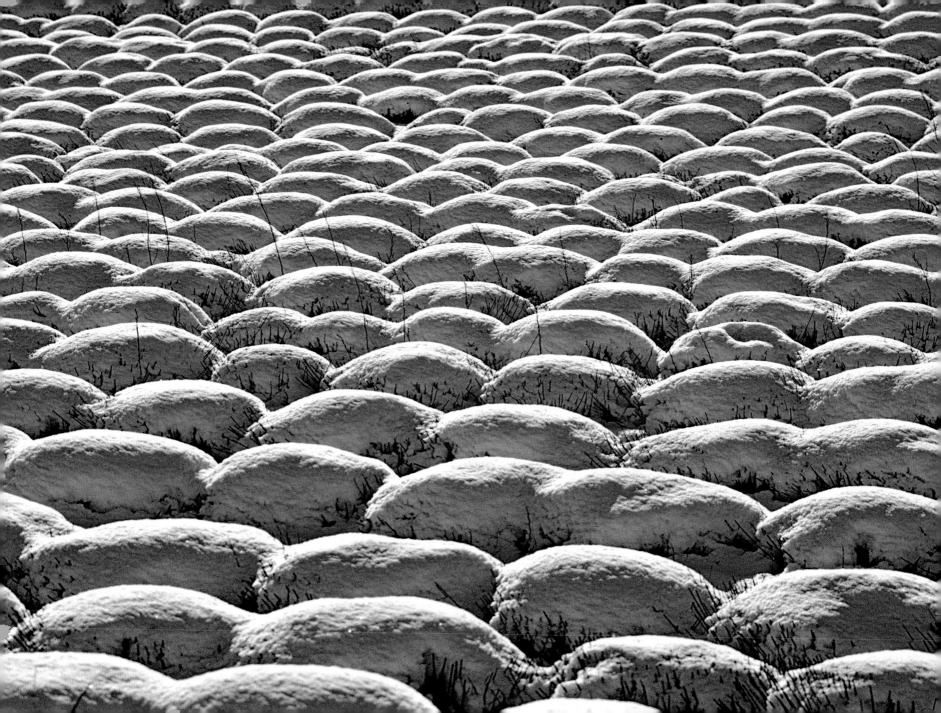

This cart, a marker of bygone days, no longer rolls through the even rows of fields.

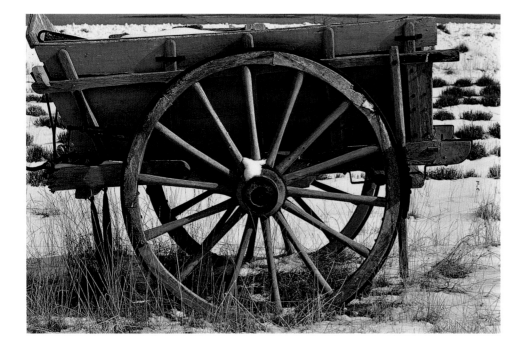

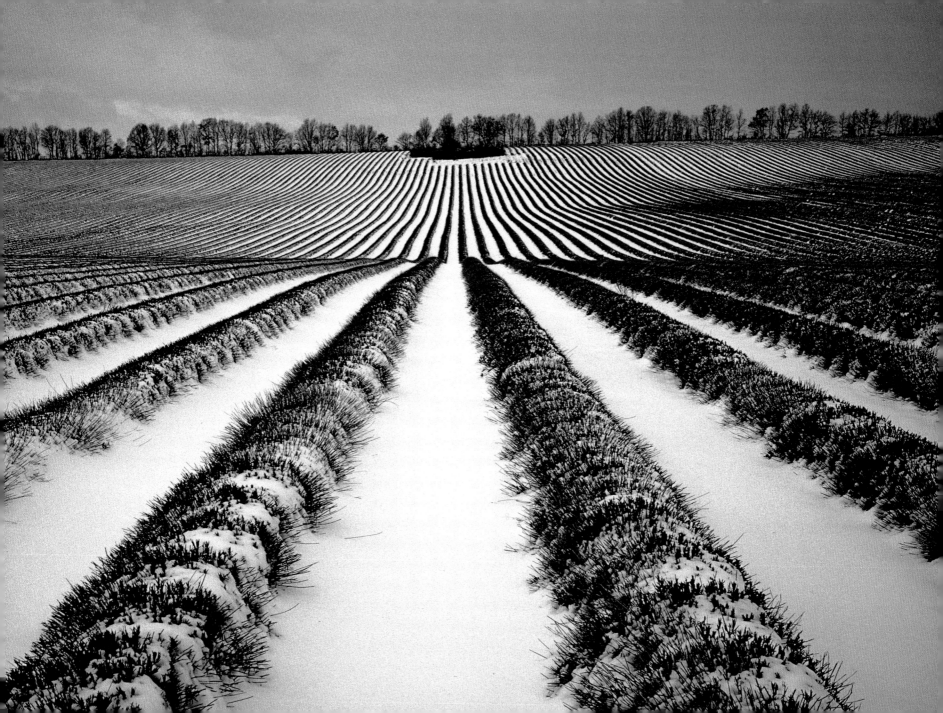

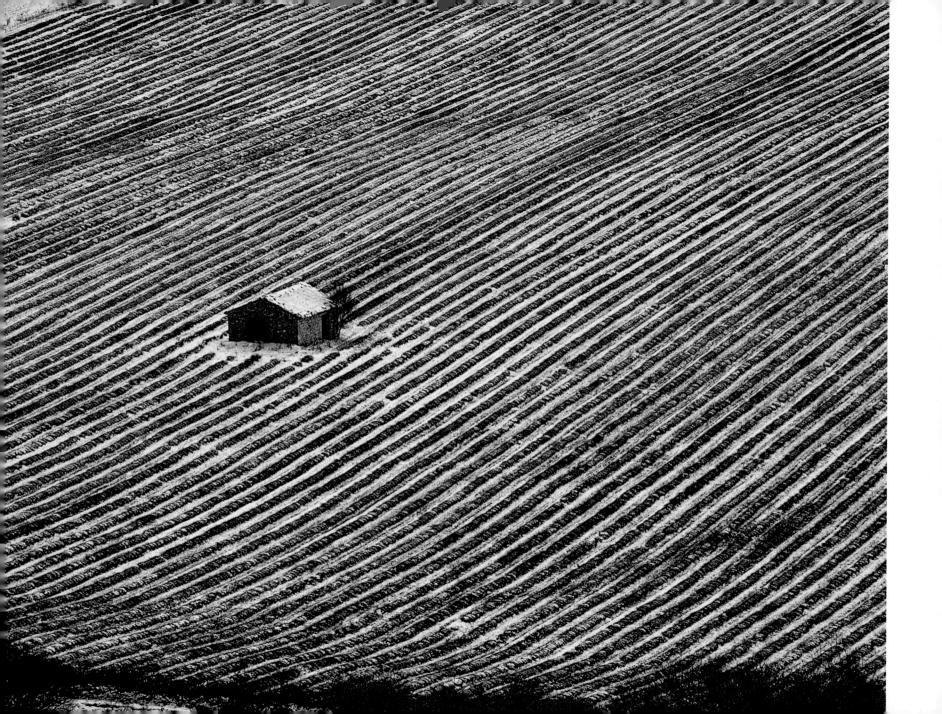

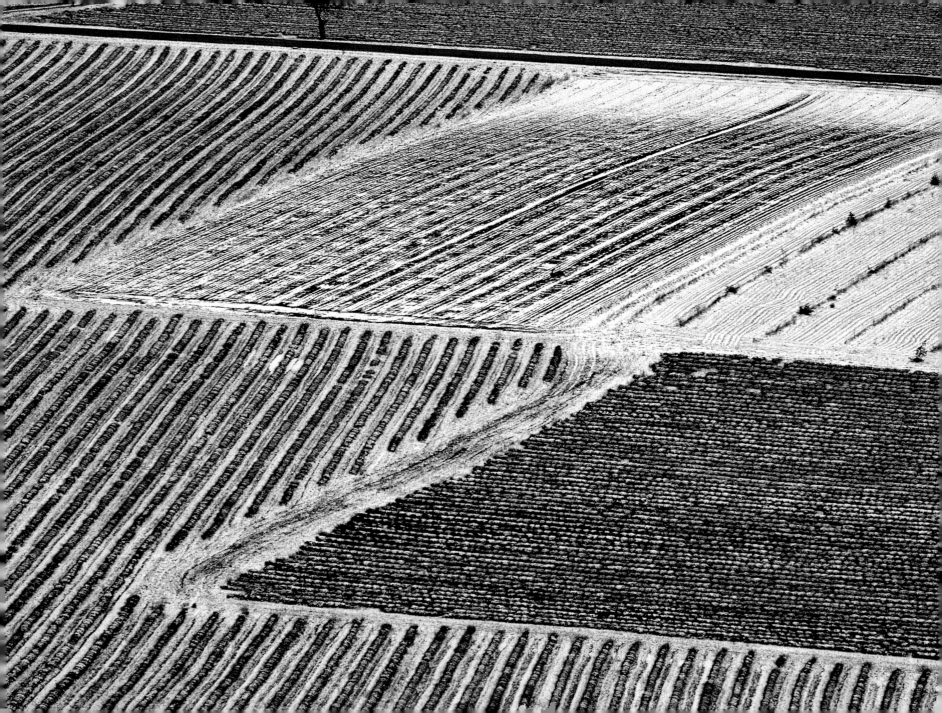

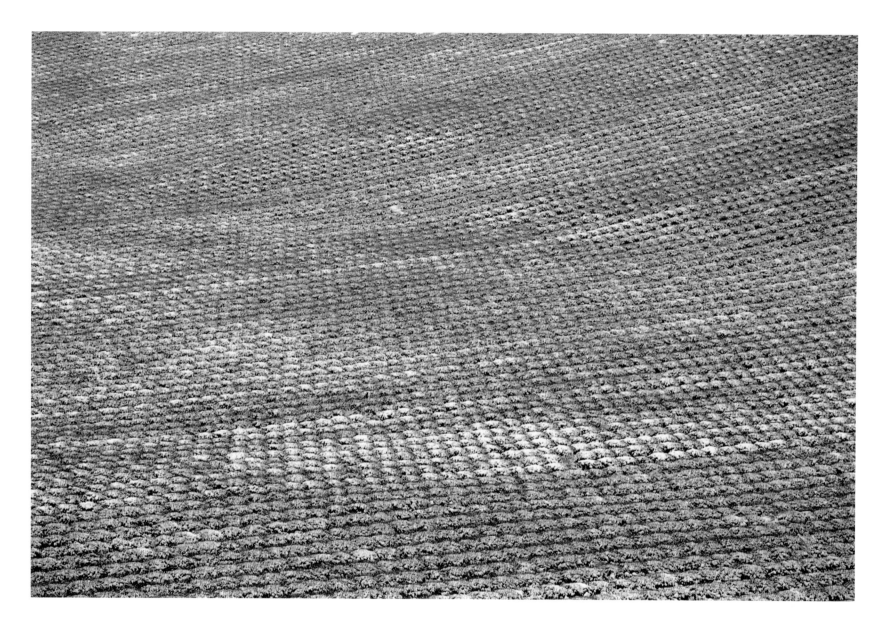

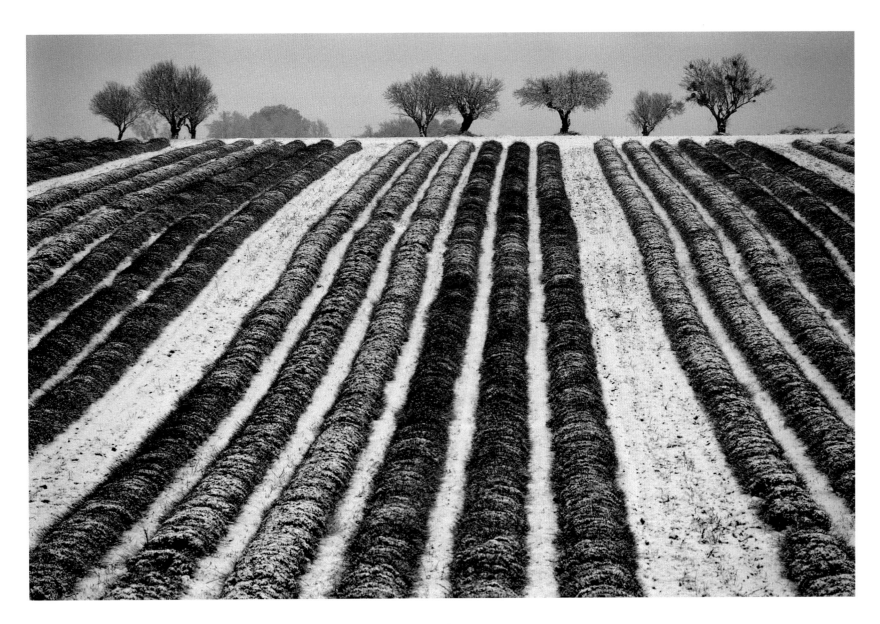

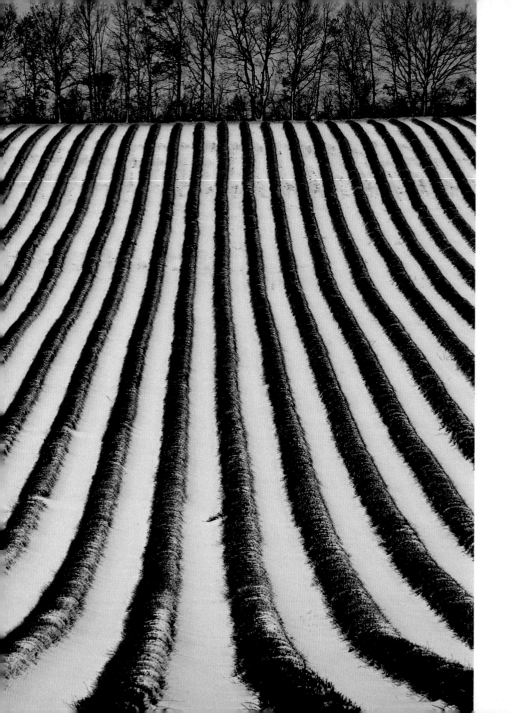

As the result of the farmers' labor

and of the snow sent from the skies,

a different, almost unreal, Provence

is skillfully drawn like an artist's

masterpiece. Is this just for our

visual pleasure?

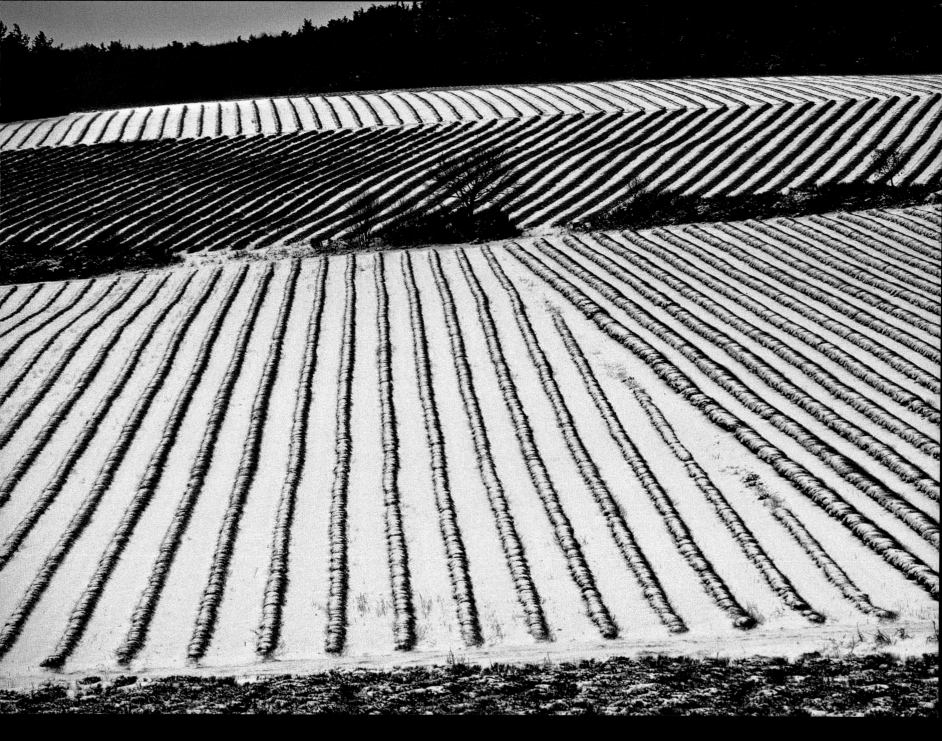

Project Manager, English-language edition: Susan Richmond
Copyeditor, English-language edition: Sylvia Karchmar
Design Coordinator, English-language edition: Christine Knorr
Production Coordinator, English-language edition: Kaija Markoe

Library of Congress Control Number: 2004101836
ISBN 0-8109-5604-7

Printed and bound in Italy
10 9 8 7 6 5 4 3 2

Harry N. Abrams, Inc.
100 Fifth Avenue
New York, N.Y. 10011
www.abramsbooks.com

Abrams is a subsidiary of

LA MARTINIÈRE
GROUPE